DRAWING *made* EASY

A STAGE BY STAGE GUIDE TO DRAWING SKILLS

DRAWING *made* EASY

A STAGE BY STAGE GUIDE TO DRAWING SKILLS

BARRINGTON BARBER

ARCTURUS

ARCTURUS

This edition published in 2013 by Arcturus Publishing Limited
26/27 Bickels Yard, 151–153 Bermondsey Street,
London SE1 3HA

Copyright © 2013 Arcturus Publishing Limited

ISBN: 978-1-78212-221-0
AD003635EN

Printed in Malaysia

Contents

INTRODUCTION

Learning to draw is not difficult – everybody learns to walk, talk, read and write at an early age, and discovering how to draw is easier than any of those processes! Drawing is merely making marks on paper which represent some visual experience. All it takes to draw effectively is the desire to do it, a little persistence, the ability to observe and a willingness to take time to correct any mistakes. This last point is very important as mistakes are not in themselves bad – they are opportunities for improvement, as long as you always put them right so that you will know what to do the next time.

Many of the exercises in this book incorporate the time-honoured methods practised by art students and professional artists. If these are followed diligently, they should bring about marked progress in your drawing skills. With consistent practice and regular repetition of the exercises, you should be able to draw competently and from there you will see your skills burgeon. Don't be put off by difficulties along the way, because they can be overcome with determination and a lot of practice and this means you are actively learning, even if it may seem a bit of a struggle at times. The main thing is to practise regularly and keep correcting your mistakes as you see them. Try not to become impatient with yourself, as the time you spend altering your drawings to improve them is time well spent.

Work with other students as often as you can, because this also helps your progress. Drawing may seem like a private exercise, but in fact it's a public one, because your drawings are for others to see and appreciate. Show your work to other people and listen to what they say; don't just accept or reject their praise or criticism, but check up on your work to see if they have seen something you haven't. If other people's views aren't very complimentary, don't take offence. Neither praise

nor criticism matters except in so far as it helps you to see your work more objectively. Although at first a more experienced artist's views are of great value, eventually you have to become your own toughest critic, assessing exactly how a drawing has succeeded and how it has not worked.

Talk to professional artists about their work if you get the chance. Go to art shows and galleries to see what the 'competition' is like, be it from the Old Masters or your contemporaries. All this experience will help you to move your own art in the right direction. Although working through this book will guide you along your path to drawing well, it is up to you to notice your weaknesses and strengths, correcting the former and building on the latter.

Steady, hard work can accomplish more than talent by itself, so don't give up when you are feeling discouraged; drawing is a marvellously satisfying activity, even if you never get your work into the Royal Academy or the Tate Modern. Enjoy yourself!

Barrington Barber

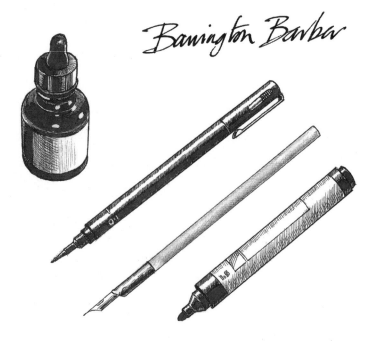

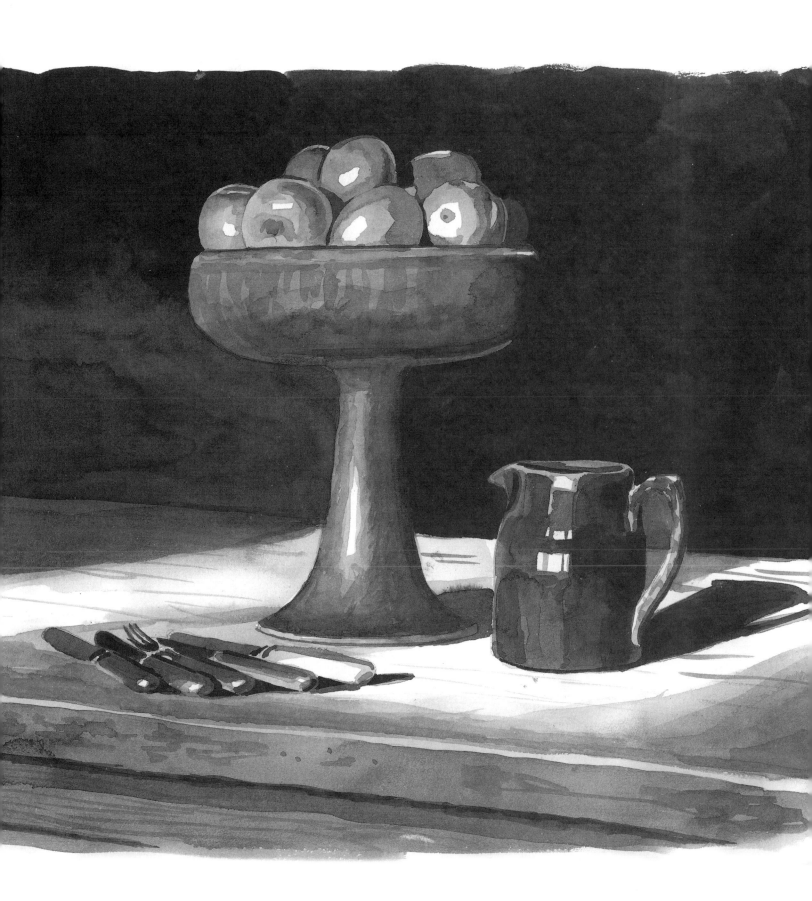

Equipment

When you first start to draw the most obvious tools to use are pencils, since you will have used these since you were a child and will feel very comfortable with them. Later on, when you are feeling more confident and preparing to take your drawing skills further, you will want to try a variety of mediums to see the different marks they make, enjoying the way you can expand your range of techniques. You will find drawing implements described on pages 78–93, with exercises to try them out on.

For your surfaces, you will need medium-weight cartridge paper, which you can buy in sheets or in a sketchbook. The latter will be most versatile, because you can take it around with you as well as using it at home. The sizes you will find convenient for travelling with are A5, A4 and A3 – anything larger is unwieldy.

A drawing board to use at home can be bought ready-made from an art supplies shop, but it's easy enough to make one cheaply by sawing it from a piece of MDF or thick plywood; an A2 size is most useful. Sand the edges to smooth them out and, if you wish, paint the board with either primer or a white emulsion to protect the surface against wear and tear. To attach your cartridge paper to the board, traditional clips or drawing pins can be used, but I prefer masking tape, which is light, easy to adjust and doesn't seem to damage the paper if it is used carefully.

Whether you draw sitting down or standing up, you will need to have your paper surface at a reasonably steep angle. If you want to draw standing up, which is usually the most accurate way to draw from life, you will need an easel to support your drawing board unless you are working with a small sketchbook. You can buy small folding easels or larger radial easels – I prefer the latter. If you like to draw sitting down and haven't got an easel, you can support an A2 drawing board on your knees and lean it on the edge of a table or the back of another chair.

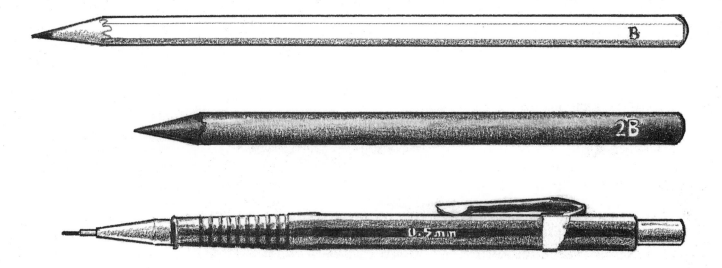

No matter whether you are using an easel or more informal support, your sight line should be such that the part of the drawing you are working on is directly facing your gaze. If you are looking at the surface from an angle oblique to the paper, you will draw slight distortions without realizing it until you step back and see the drawing more objectively. Keep the grip on the pencil, or whatever implement you are using, fairly light and relaxed – you don't need to hold it in a vice-like grip. Also try different ways of drawing with the pencil, both in the normal pen grip and also in the brush grip, especially when you are drawing standing up – the more vertical your surface, the easier it is to use the brush grip.

Keep relaxing your shoulders, arm and wrist – a smooth, easy action is more conducive to good drawing. If you realize your movement is becoming anxious and constricted, stand back from the easel a little and work with sweeping strokes until you feel your action loosening again. As a beginner it's all too easy to become tense, perhaps through worrying that you are about to spoil a drawing that has been going well so far, but remember you are doing this for pleasure! The exercises in this book should help you to enjoy the learning process and concentrate on your progress rather than your mistakes.

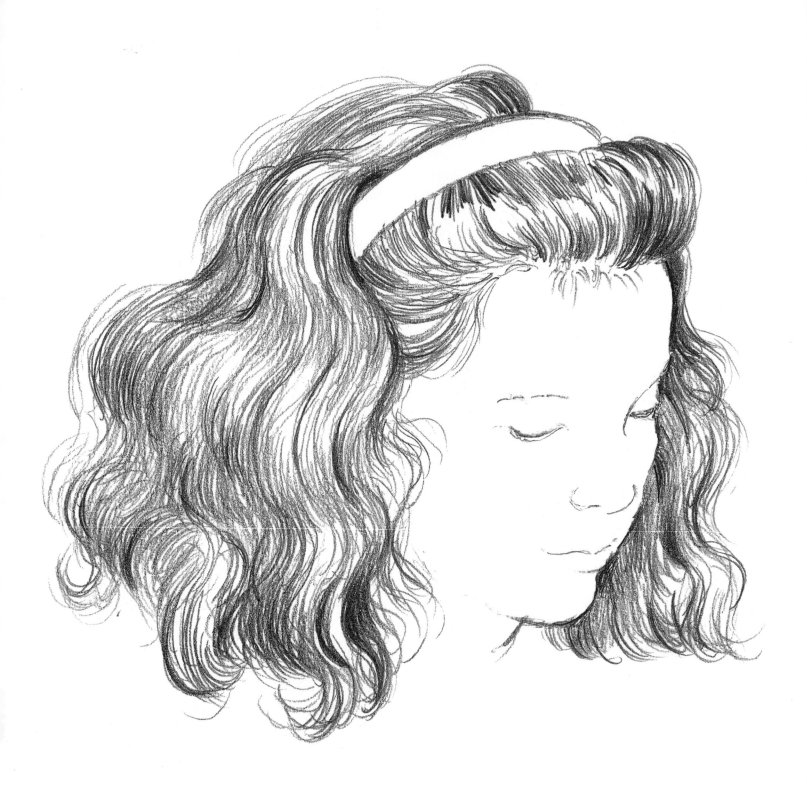

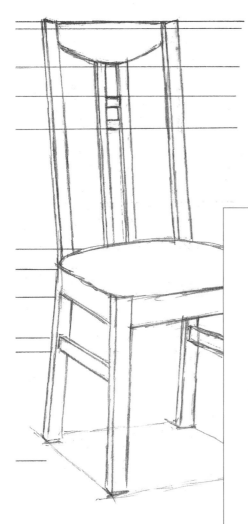

Lesson 1

BASIC EXERCISES IN LINE, SHAPE AND TEXTURE

This lesson is primarily designed for people who haven't done very much drawing, but even if you are already quite practised you may find that carrying out the exercises shown here is a good way to loosen yourself up for what follows. The main point of them is to work on the basic skills necessary to draw anything with some degree of verisimilitude. The practice of making marks, which after all is what drawing consists of, never loses its usefulness however accomplished you become.

So included in this section are exercises in drawing lines, tones, textures, and then simple shapes. All of the latter need a certain amount of control of the pencil, and practising this is never time wasted. You will also find lessons in simple perspective to introduce you to the practicalities of drawing shapes that appear to have some dimension.

These are followed by drawing the outlines of objects you have in front of you in order to familiarize yourself with working from life. This is where the real skill of an artist is honed, and it is something that you will never stop practising if you want to draw well. Finally, you will find exercises that give you some practice in adding texture to the objects that you draw in order to make them look more realistic.

MARK MAKING

These exercises are mainly for the benefit of complete beginners in drawing, but even if you are reasonably competent they will still be of great benefit. It is practising every day that produces manual dexterity, which is essentially what the artist needs. The more often you follow exercises such as

these the more your hand and eye learn to work together, making your drawing more skilful.

Don't ignore the aesthetic quality of making marks; try to make your group of exercises look good on the paper.

Exercise 1

Start by making a scribbly line in all directions. Limit it to an area and try to produce a satisfying texture.

Next try short, staccato marks that fill the space. Notice how none of them overlap and the spaces in between remain similar.

When you are drawing these more controlled uniform lines, make them all the same length and the same distance apart, keeping them as straight as possible. Repeat these three exercises.

Now take a line for a walk, but don't cross over it anywhere. This may seem rather obsessive, but it is a step on the way to teaching your hand to draw recognizable forms.

Next try a variety of straight lines, again trying to get them straight and the same distance apart, fitting into an imagined rectangle. First do diagonals from lower left to upper right, then horizontals, then diagonals from upper left to lower right. Next, try the two diagonals across each other to form a net, then the horizontals and verticals in the same fashion.

To practise more circular forms, make spirals. Work from outside to inside, clockwise and anti-clockwise, then tighter with the lines closer together; next work from the centre outwards, anti-clockwise then clockwise.

Now zig-zag your pencil up and down.

Use the same action, but incorporate some loops.

Try to produce a dark mass with lines going up and down.

Next, lay another mass of lines horizontally over this dark mass.

Finally, add third and fourth layers, both at diagonals.

Exercise 2

The next exploration in mark making is to draw a mass of zigzags in a continuous line crisscrossing over itself.

Now make softer, curvy lines overlapping themselves.

And now cloud-like shapes, going round and round in a continual line overlapping itself.

Next come small circles – lots of them, lined up both horizontally and vertically.

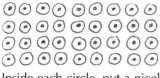

Inside each circle, put a nicely drawn spot.

Next make a network of vertical and horizontal lines, drawn very carefully.

Spread a mass of dots over an area as evenly as possible. Remember that this is training for the eye as well as the hand, so the evenness of the dots is important.

Draw several rows of small squares in lines as evenly as possible, as square as possible and lined up both vertically and horizontally.

This exercise is a bit harder to draw evenly, but try it anyway. Make rows of triangles fitting together so that the space between them is as even as possible and they are lined up horizontally and vertically.

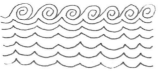

Draw rows of spirals joined together as if they were the waves on the sea. Under them draw rows of waves, again as even as you can get them.

For the rest of the exercises on this page, the emphasis is on lightness of touch and control of the direction.

The first one is a vague circular shape of closely drawn lines, light in pressure to create a shaded area of tone.

Using the same technique, draw horizontal lines.

Next, make them vertically.

Then draw them diagonally, slanting to the left.

Again working diagonally, start dark with some pressure, gradually lightening the touch until it fades away.

Now make a series of similar shaded areas, starting from a curved drawn line so that one edge is defined.

Shade away from a zigzag edge.

Then shade away from an S-curved edge.

Now draw a circle and shade inside and outside of opposite edges.

Finally, do the same again only with two circles, one within the other.

BASIC SHAPES

So far, the exercises you have done with your pencil have been a bit like doodling. The next phase is a rather more intellectual one, where you have to envisage a form in your mind before trying to draw it.

Exercise 1

First, without too much thought, draw a circle as perfectly as you can. Now close your eyes and see a perfect circle in your mind's eye. It is extraordinary how we can do this yet draw something much less than perfect.

For your second attempt, draw one very lightly with a compass and then go over it in freehand, teaching yourself the way the shape should look. With practice of this kind it won't be long before your freehand circles have improved.

Now try an equilateral triangle – that is, a triangle that has all three sides equal in length. Not quite so easy as it looks, is it? But there is also a mechanical device to help you here: describe a circle with a compass, then draw the triangle within it, all angles touching the circle.

Next, a square. You will know that all the sides of a square are equal in length, and the corners are all right angles, but it can take a bit of time to get that right in the drawing. The mechanical device here is to measure the sides.

Because you are not used to seeing it so much, it is not so easy to draw a square balanced up on one corner, like a diamond shape. You will find it harder to get the sides equal.

Now we move on to slightly more complex shapes. The point of this is to get your eye, brain and hand acting together, so that gradually the practice of drawing becomes easier.

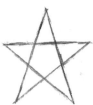

First, draw a five-pointed star without lifting your pencil from the paper. This is also easier drawn inside a circle with all the angles touching it, but try it with and without.

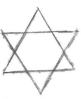

Secondly, try a six-pointed star, which is merely two equilateral triangles superimposed on one another.

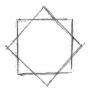

Thirdly, draw a star of eight points, which is one square superimposed on another square.

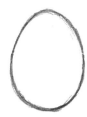

Now try an egg shape. This is narrower at one end than the other; draw it with the broader end at the base.

The crescent is another shape much harder than it looks at first glance, but the secret is to realize that the curve is a part of a circle. Try it freehand and then with a compass-drawn circle to help.

Exercise 2

In this exercise we start to look at ways of making things appear three-dimensional, in a conventional way – that is, they are only approximations of perspective, which is the way we tend to see shapes in space.

Draw a square, then another the same size but slightly above and to one side of the first. Join the corners with straight lines to link them up, giving a result like a transparent cube.

The next figure is similar, but put in only three of the joining lines so that the cube looks solid rather than transparent.

Now another way of drawing a cube; draw a flattened parallelogram, like a diamond on its side, and then project straight vertical lines down from the corners of this shape to another diamond shape below.

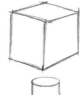

This time draw only three of the joining lines and two edges of the lower diamond, so that the cube looks solid again.

Next, draw a cylinder. First draw an ellipse – a flattened circle – then project two parallel lines vertically downwards to meet a similar ellipse.

Try again, only this time leave out the upper edge of the lower ellipse to make the cylinder look more solid.

Reverse the process so that the upper ellipse has only one edge; the cylinder now appears to be seen from below.

Now move on to cones, which are just two converging straight lines with an ellipse at the wider end.

Try this without part of the ellipse and then with the cone balanced on its point.

Exercise 3

You won't have found any of those exercises difficult after a bit of practice. The next stage is to practise making areas of tone on spheres, cubes, cylinders and cones.

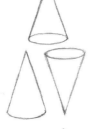

First draw a circle as accurately as you can. Now, with very light strokes, put an area of tone over the left-hand half of the circle. Increase the intensity in a crescent shape around the lower left-hand side of the circle, leaving a slight area closest to the edge to act as the reflected light that

you usually get around the darker side of the sphere. Put in the cast shadow on the area that would be the ground, spilling out to the left and fading as it gets further from the sphere.

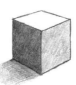

Now have a go at a cube, covering the left-hand side with a darkish tone. When this is dark enough, cover the other vertical side evenly all over with a much lighter tone. All that is needed then is a cast shadow as before, but fitting the squarer shape of the figure.

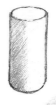

A cylinder is similar to a sphere, but the shading is only on the vertical surface. Again make a column of darker tone just away from the left-hand edge.

With a cone you have to allow for the narrowing shape, which is reflected in the cast shadow.

15

SIMPLE PERSPECTIVE

In order to draw in a way that gives an effect of three dimensions you will need to learn a little about perspective, which is a way to make depth and space look more convincing. In life, perspective gives us an ability to assess the placing of objects and people in relation to one another, and you will need to mirror this in your drawings to make them realistic.

Exercise 1

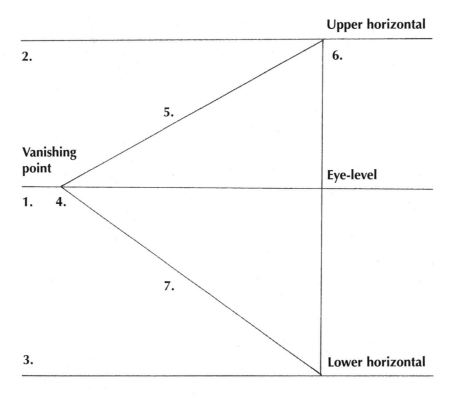

First, construct three horizontal lines that are parallel to each other across the page. The central one should be slightly nearer the top line than the bottom line. This central line **(1)** represents your eye-level, which will always be the line of the horizon. The others are the upper horizontal **(2)** and the lower horizontal **(3)**.

Now, to the right of the centre of your space, draw a vertical line from the upper horizontal to the lower horizontal **(6)**. Fix a point on the eye-level line and join the two ends of the vertical line to this point, which is called the vanishing point **(4)**. These two lines are the upper perspective line **(5)** and the lower perspective line **(7)**. You now have a triangle connecting the three horizontals and the vertical.

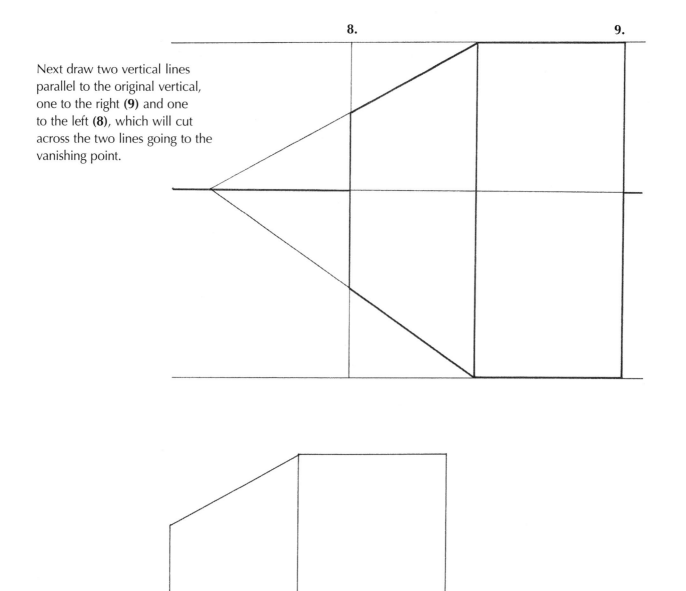

8. **9.**

Next draw two vertical lines parallel to the original vertical, one to the right (**9**) and one to the left (**8**), which will cut across the two lines going to the vanishing point.

You can now erase the construction lines to leave an apparent solid block such as a box or a building, with the horizon line across the back behind the object. This gives you a three-dimensional object in space which convinces the eye.

OBJECTS AND SHADING

The exercises over the following pages should be fun, so try to feel at ease as you do them. Don't grip the pencil too tightly, keep your shoulders relaxed and don't hunch up or get too close to your work. Draw what interests you and don't worry about mistakes – just correct them when you see them. To do this next set of exercises you will need to have some simple household objects in front of you.

I have chosen some items from my own house – yours don't have to be exactly the same, but it will help you to follow my drawings while you work on the actual object in front of you.

Before you start, look very carefully at each object to familiarize yourself with its shape. I have used glass objects for the first exercises, because you can see through them to understand how the shape works.

Exercise 1

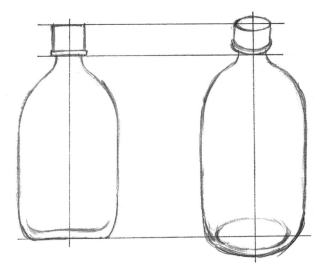

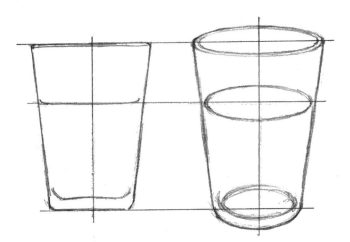

My first object is a bottle, seen directly from the side. As it was exactly symmetrical, I put in a central line first. Then I drew an outline of its shape including the screw top, making sure that both sides were symmetrical.

From a higher eye-level, I could see the bottle's rounded shape. To show this I needed to draw the elliptical shapes that circles make when seen from an oblique angle. Again I carefully constructed the shape either side of a central vertical line.

The ellipses shown below demonstrate how they become flattened to a greater or lesser degree depending upon the eye-level from which a rounded object is seen.

Although they become deeper across the vertical axis the further they are below your eye-level, the horizontal axis remains the same width. Don't be put off by the difficulty of drawing them, because even professional artists don't find them so easy; with practice, you will be able to draw them well.

The next object is a glass tumbler with some water in it – slightly easier to draw than the bottle because it has straight sides. Draw the outline first at eye-level and then seen from slightly above. In the latter drawing there are three ellipses: the top edge of the glass, the surface of the water and the bottom of the glass.

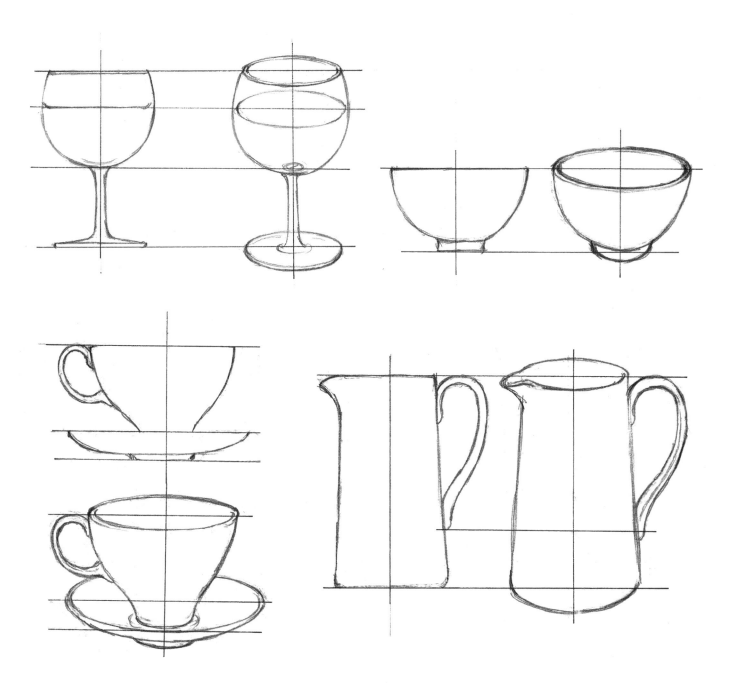

The third object, a wine glass with some liquid in it, is a bit harder. Here you will see that there are three ellipses of varying width, but the object is still symmetrical from side to side. Go carefully and enjoy discovering the exact shape.

Next, some opaque subjects, starting with a bowl. The side view drawing is easy enough; make the curve as accurate as you can, and then tackle the view from just above. This time you aren't able to see through the sides, so you have only one edge of the lower ellipse to draw.

The cup and saucer is more complex, but with a bit of steady care and attention you will soon get the shape right. Drawing it from above is a little harder and because you can't see through the porcelain it might be trickier to get the lower ellipses right first time.

The jug should be a bit easier after the cup and saucer, and it is placed here on purpose so that the effort you make on the more complex drawing pays off on the easier one. As before, draw the exact side view first before you depict it more naturally, seen from slightly above.

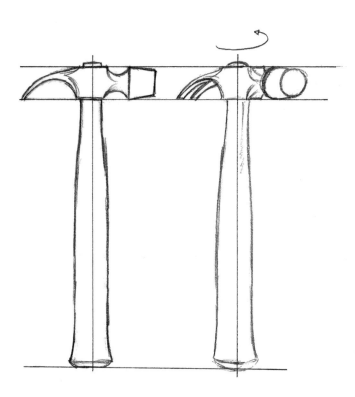

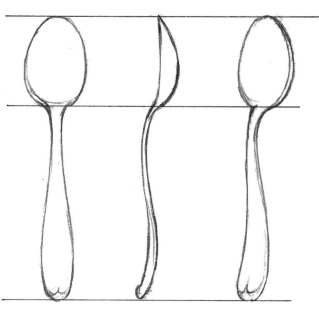

Exercise 2

Now you're ready to move on to a series of objects which are of varying difficulty. The drawing of the hammer is quite easy from the exact side view but is a bit trickier from a more oblique view.

There are two ways to draw the spoon, from the exact front and from the exact side, before you try a more natural view.

The pot is not too difficult if you have completed all the other objects so far, and the box is very simple – but beware of the third version, a slightly more complex view where the perspective can easily go wrong.

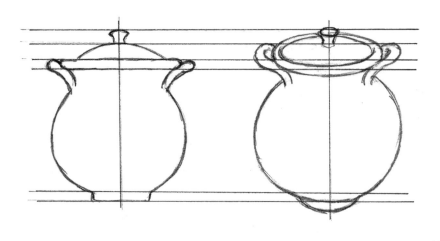

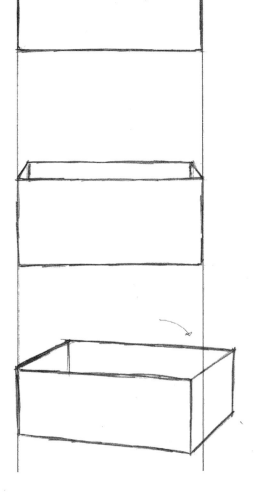

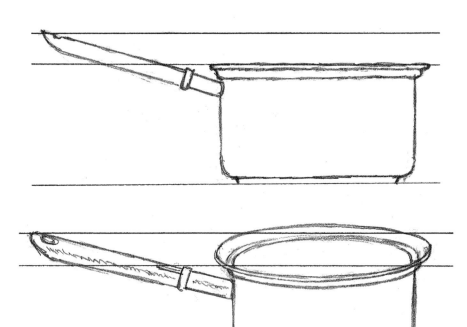

The saucepan and the teapot are of varying difficulty, but by now you are getting used to the problems of drawing like this. This sequence of objects is merely to give you practice in drawing, doing as many as you can in the time you have available.

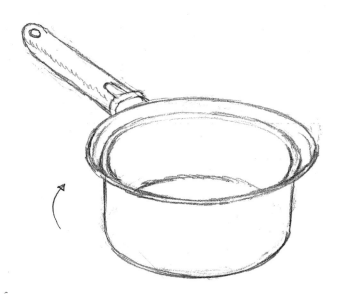

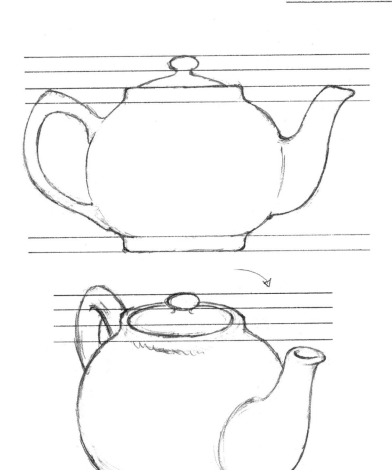

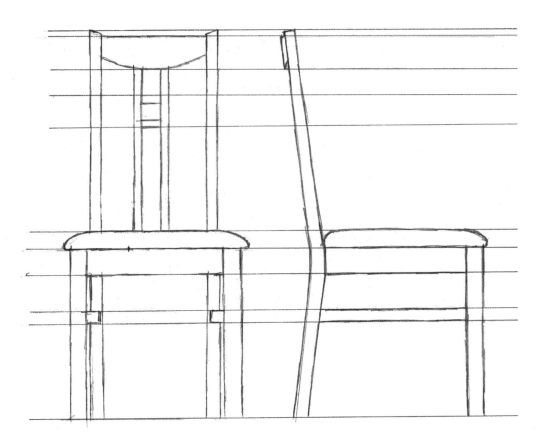

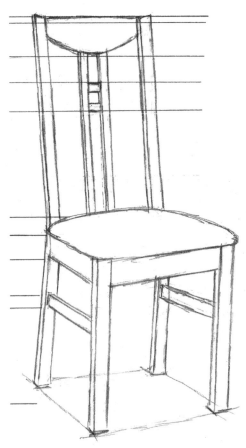

The chair is more complex than it looks at first glance. Follow the same course of drawing it from the exact side and front before trying to draw it in perspective. Understanding the construction of the chair is useful when you are trying to draw it.

Exercise 3

All these objects are simple enough in outline. However, to make them look more three-dimensional and substantial, the use of shading of some sort is needed.

First make line drawings of the objects as accurately as possible. On the book, shading to show the curve of the spine and fine lines giving an effect of the packed pages is almost all there is to do, with the addition of a small cast shadow to anchor it to a surface.

The pot needs quite heavy tone in the interior space to give some idea of the inner hollow. Then add a graduated tone around the cylinder and a small cast shadow to complete the picture.

The apple needs to be shaded in a vertical direction between the upper surface and the bottom, concentrating on the left-hand side to indicate the direction of the light. Also add a cast shadow and some shading where the stalk comes out of its hollow.

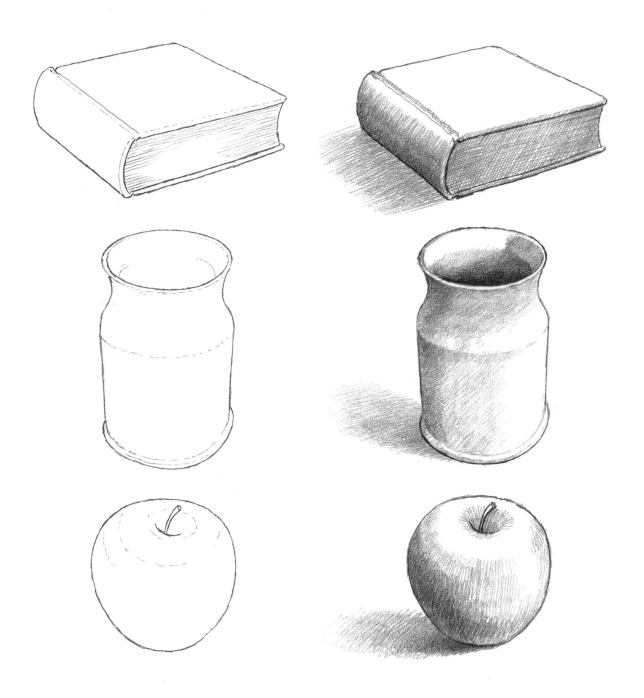

TEXTURES AND MATERIALITY

Here we look at developing a feel for different types of materials and transferring their textural qualities on to paper. As in the first exercises on pages 12–13, take care over the appearance of your drawings as a group.

Grass

The first of these drawings of texture shows an impression of an area of grass-like tufts – that is to say, very conventional patterns that resemble grass, not drawings taken directly from life. When you have tried the stylized version, you could go and look at a patch of grass and try to draw that from life.

Wood

Now try doing this wooden plank, with its knots and wavy lines of growth. The floorboards in your house might be a good example of this kind of wood pattern.

Beach

Next, a drawing that resembles a pebbled beach, with countless stones of various sizes. Again, after drawing a conventional version like this, you could try working with a real area of pebbles or stones.

Mesh

This carefully drawn mesh looks a bit like a piece of hessian or other loosely woven cloth. Make sure that the lines don't get too heavy or the cloth-like effect will be destroyed.

Fur

This resembles fur, such as on a rug or the back of a cat. The short, wavy lines go in several directions, but follow a sort of pattern.

Rock

This drawing shows the surface of what might be a piece of grained and fissured rock. Again, after trying out this example, have a look at the real thing which will show you how comparatively stylized this pattern is.

Clouds

This smoky texture is produced by using a soft pencil, then a paper stump to smudge the dark areas. After that, a little rubbing of some of the darker parts gives a cloudy look.

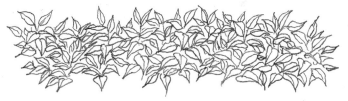

Leaves

All that is needed to give the effect of thick, hedge-like leaves is a large number of small leaves drawn adjacent to and overlapping each other. Try to maintain a certain amount of variety in the angles of the leaves to make them more convincing.

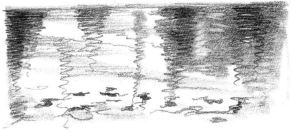

Water

This watery texture is achieved by keeping all the marks you make horizontal and joined together to create the effect of ripples. Smudge a little of the drawing to create greyer tones, but leave some untouched areas to look like reflected light.

Brick

This brickwork effect is not difficult but is a bit painstaking. The trick is to keep the horizontals as level as possible but draw the edges rather wobbly, which gives the rather worn look of older bricks. Smudge some tone on some of the bricks, varying it rather than making it even.

Snakeskin

Drawing snakeskin or fish scales is just a matter of drawing many overlapping scale shapes without being too precise or you will lose the movable look of natural scales. Again, it requires a rather painstaking effort, but apart from that it is easy.

Drapery

This drapery is done by drawing descending curves to emulate cloth, and then using a paper stump to smudge and soften the edges of the tone. The only sharp lines should be at the sides where the cloth appears to be gathered up.

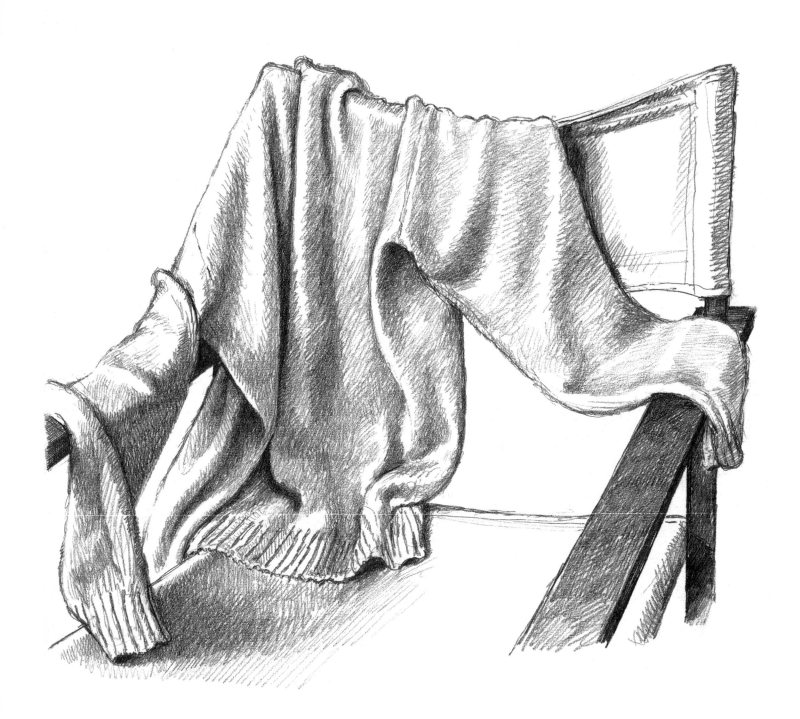

Lesson 2

FORM AND TONE

This series of exercises is all about trying to make the shape of the objects you draw look more realistic by establishing their form in more detail. In order to do this you will also have to keep working on your drawing of outline shapes and build further on what you have already begun to learn about tone.

So, starting off with carefully drawn shapes, you need to follow this up with adding tone and shading to the forms to give a feeling of solidity. This needs quite a lot of practice, so there are many variations in the objects I have given you to draw. You will also begin to see how the methods that you use in one drawing can easily be adapted for other things that at first glance seem very different. The more you can practise these methods the better you will become at drawing.

One thing you will come to realize is that there is no such thing as a difficult or easy drawing; they all have the same degree of difficulty, although some may take longer because there is more complexity in the shape. Drawing only becomes easier with increased skill, and then of course you draw more extensively so the challenges also increase. One of the great things about art is that you never come to the point where you know it all – there is always further to go.

DEVELOPING FORM AND TONE

To start our investigations into developing form, we look at two objects, a thermos flask and a tumbler, made of metal and glass respectively. Whereas the flask needs a building up of tone to show its rounded form and the darker parts of the metal, the glass tumbler needs only minimal shading, because it is transparent.

First just draw the outline shapes of the objects and in the vacuum flask mark where the edges of the brightest and darkest areas of tone are to be. In the glass tumbler just put in the edge shapes of the moulded glass and the surface of the water.

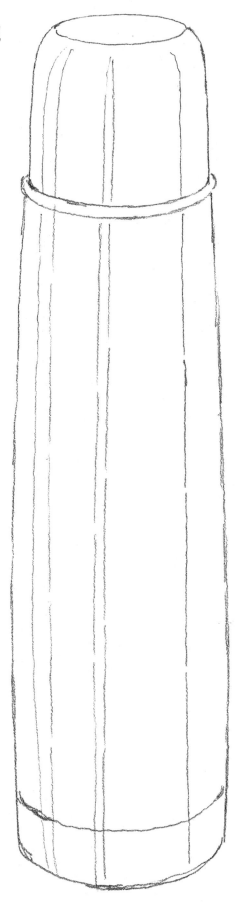

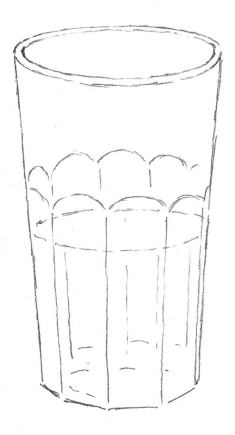

28

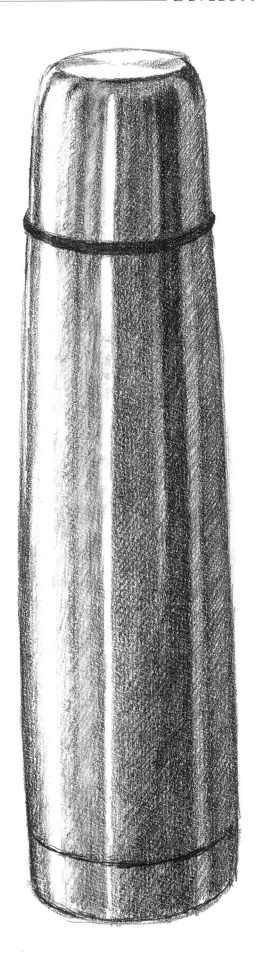

Having done this, put in all the darkest tones on the flask as smoothly as you can. Gradually fill up all the other areas where the tones are less intense, making sure that you leave the brightest bits totally white, clean paper. When you have covered all the areas of tone, study the whole drawing to see if you need to strengthen any of the darkest parts.

With the glass tumbler the trick is not to do too much shading. Put in the very darkest parts first, noticing that there are not very many of them. Then add the medium and lightest tones, underdoing the tone rather than overdoing it. When you think you've finished give it a careful look to see if any tones really need to be strengthened, and then stop before you overwork it.

At first you might not be very successful in your efforts, but as you continue to practise you will soon develop the necessary skill to make your work look more convincing.

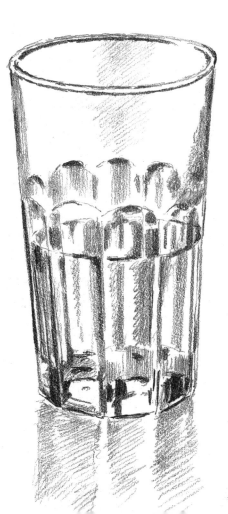

A Still Life With Line and Tone

To set up a simple still-life arrangement, take some ordinary everyday objects that are not too complex in shape. My particular choice was a teapot, a jug, a sugar bowl, a cup and saucer and a spoon. These had the benefit of being both immediately to hand and familiar. I put them on a small tray to limit the area to be drawn. This meant that they all overlapped each other from my viewpoint, which forced a composition on the picture without my having to choose one.

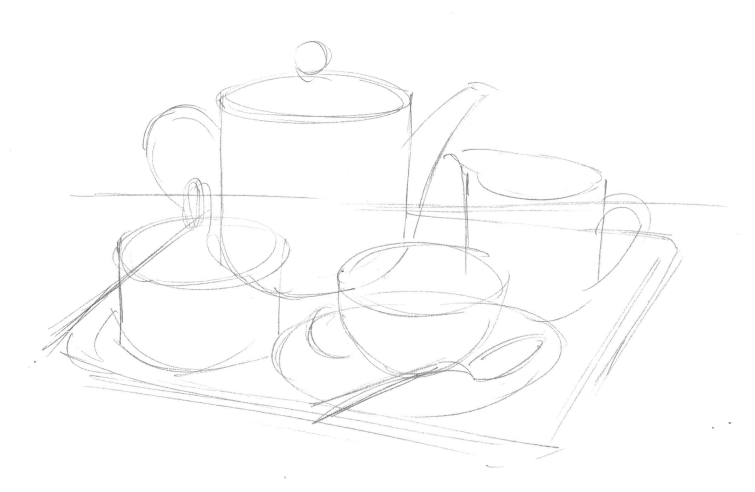

Step 1

So now I had my still life in front of me, and I needed to assess the whole picture in a simple way that helped me to start the drawing. With very light strokes I indicated the main shapes of the group of objects very loosely, altering and erasing any marks that didn't look like the group of shapes I could see. At this stage the main point of the exercise was to get a very simple idea of all the shapes together and their relative sizes and forms.

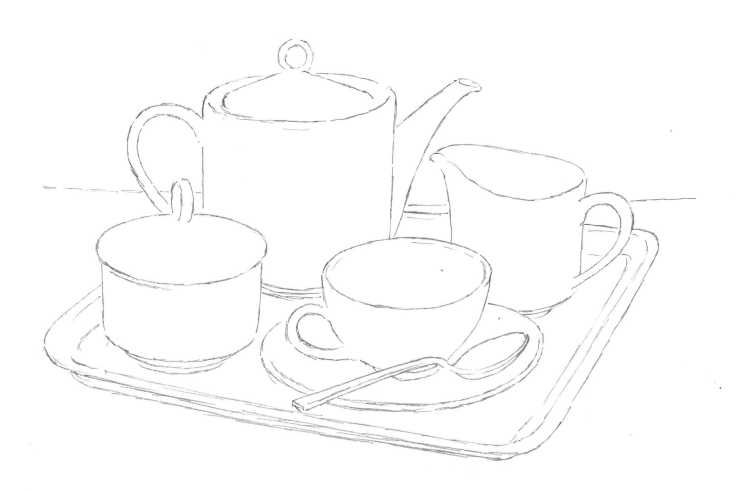

Step 2

Having arrived at a satisfactory set of forms, I now needed to define them more accurately. This meant carefully drawing an outline of each object, showing how they overlapped each other and how each shape was formed, this time very decisively. I was then left with a complete outline picture of the whole still life. Redraw any obvious mistakes you see in your own work – it is easiest to correct the mistake first and then erase the lines that are not correct.

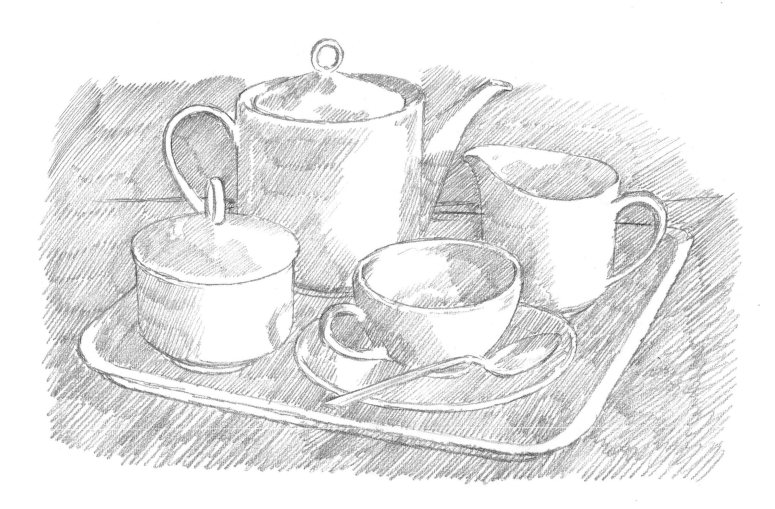

Step 3

With the essence of the picture complete, I could turn to the tonal values
that would help me show the three-dimensional qualities of the forms. At this
stage I put only one depth of tone all over, except for areas of white paper that
would act as highlights. When this was finished the whole picture had taken
on a more solid look.

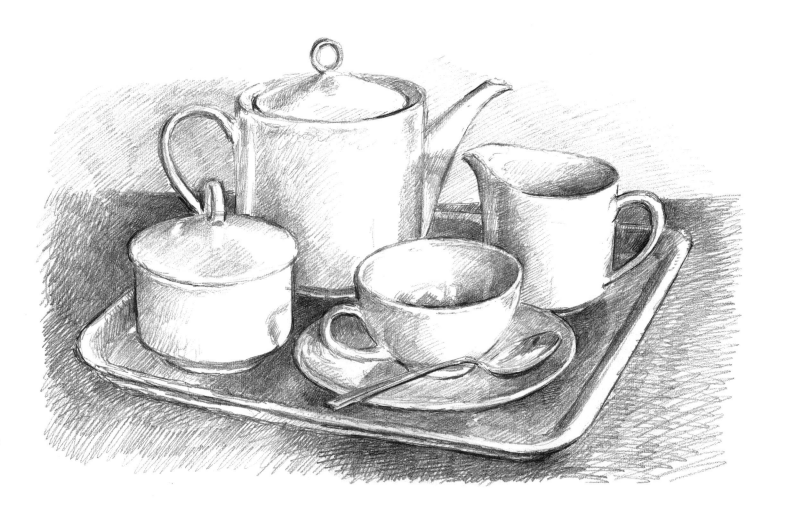

Step 4

The final stage of the drawing was an exercise in seeing which areas were much darker than all the others and which less dark. I find the best way to deal with this is to do the very darkest areas first and then gradually add any tone required to the less dark places. As you can see, quite large areas have a fairly dark tone, especially the table-top and the surface of the tray. When I am satisfied that the tones in a drawing match the tones that I can see on the objects, I know that my shading exercise has finished. If any areas are a little too dark I can gently drag an eraser across the tone to lighten it.

This exercise may take you some time to complete, and if you find that it is becoming a chore you should stop and continue some time later – it doesn't matter if it takes longer than one session.

DRAWING A HEAD AND FACE

This exercise is one for which you will need a model. If someone you know will sit for you for an hour you can draw their face, but if this is difficult, simply position yourself in front of a good-sized mirror and draw your own.

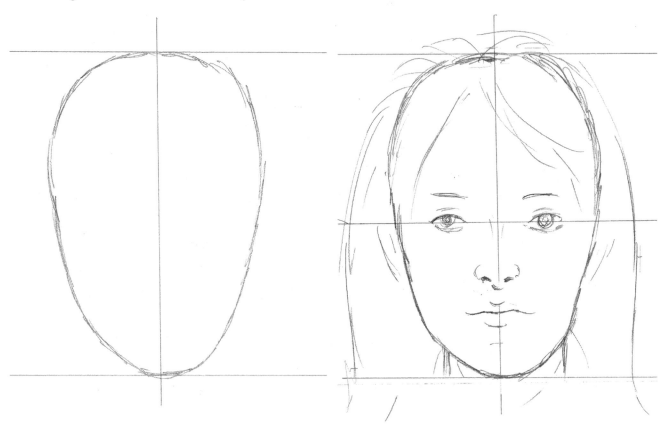

Step 1

To start with you need to draw a straight-on, full-face view, so that you can understand the proportions of the human head. Make a mark at the top of the page to indicate where the top of the head is going to be, and another where the point of the chin will go. Don't make the distance between these two points bigger than the size of the model's head, although it doesn't matter if it is a bit smaller. Now draw a line straight down to join the top mark to the bottom. This indicates the centre of the head vertically. All the shapes you are going to draw should be evenly balanced each side of this line.

Looking carefully at the shape of the head in front of you, whether your own or your model's, have a go at drawing the oval shape of the whole head – and I mean the whole head, not just the face. You'd be surprised how many beginners draw the head as though there is nothing much above the hairline.

Step 2

Draw a horizontal line halfway down the head to show the level of the eyes. Mark in the position and shape of the eyes on this line. The distance between them is the same as the length of the eye from corner to corner.

Then mark in the end of the nose, about halfway between the eyes and the point of the chin. Draw just the nostrils and the bottom edge of the nose. Next draw the line of the mouth, which is slightly nearer the nose than the chin – it is usually positioned at one-fifth of the whole head length from the bottom of the chin. Draw the shape between the lips, then, more lightly, put in the shape of the upper lip below the nose and the fold under the lower one, not the edge of the lip colour.

Mark in the hair, the position of the ears, if they can be seen, and the eyebrows. The tops of the ears and the eyebrows are at about the same level. So now you have the basic head with its features put in.

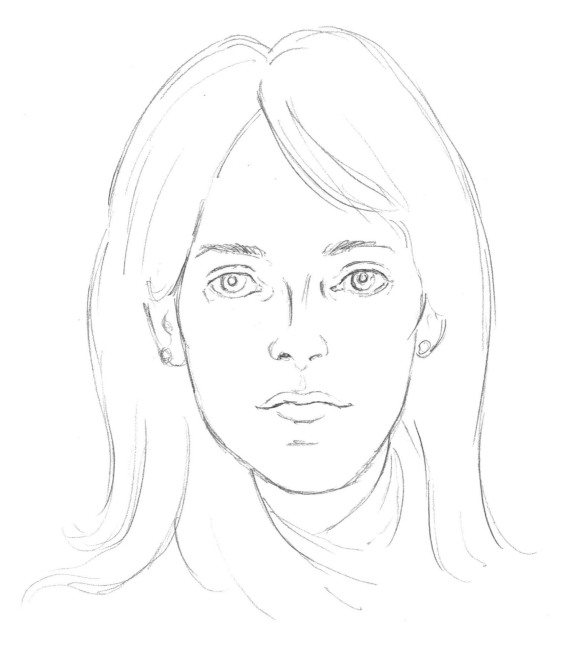

Step 3

The next stage is to draw all the features and the hair, correcting any mistakes as you go. Look at the thickness of the eyebrows and note that the shape of the inner corner of the eye is different to that of the outer. If the eyes are looking straight at you, the iris is slightly hidden by the upper eyelid and usually touches the lower one. You can't see a great deal of the ears from this angle, but try to get the shape as accurately as you can.

The most important areas of the nose are the under part and the shape of the nostrils. There are usually marks that you can draw lightly to indicate the area where the nose is closest to the eyes and there may be a strong shadow showing the bonier part of the nose – but mark it in only lightly, or it will look like a beak.

The mouth is a bit easier, but remember that the strongest marks should be reserved for the line where the lips meet; if you make the edges of the lip colour too strong it will have the effect of flattening the lips. There is usually a strong fold under the lower lip which can be more defining of the mouth than the edge of the colour.

The outline of the jaw and cheekbones is important to show the characteristics of the face in front of you. If you make the jaw too large or small it will look clumsy or weak respectively, so take your time to get this right.

The hair is also important, especially where it defines the shape of the skull underneath. If it's too big your model will look like an alien, while if it's too small the head will appear to lack enough space for brains.

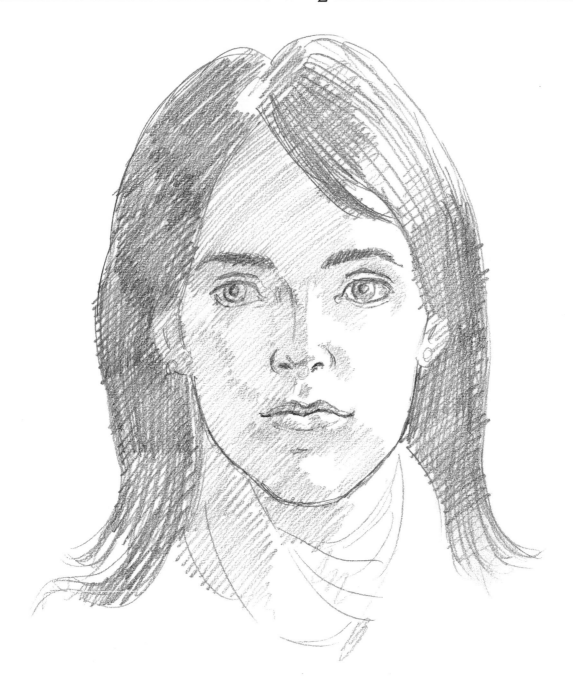

Step 4

Now you can start to mark in the shading on the face and hair, putting it all in at the same strength. There will usually be light coming from one side, and in my example the left side of the face is in some shadow and the right side is in more light. This stage is where the projecting features such as the nose, eyebrows and mouth start to show their form.

Shade the hair in the same way, but take the marks in the direction that the hair grows. If the hair is dark, put another layer of tone everywhere except where the light shines strongly on it.

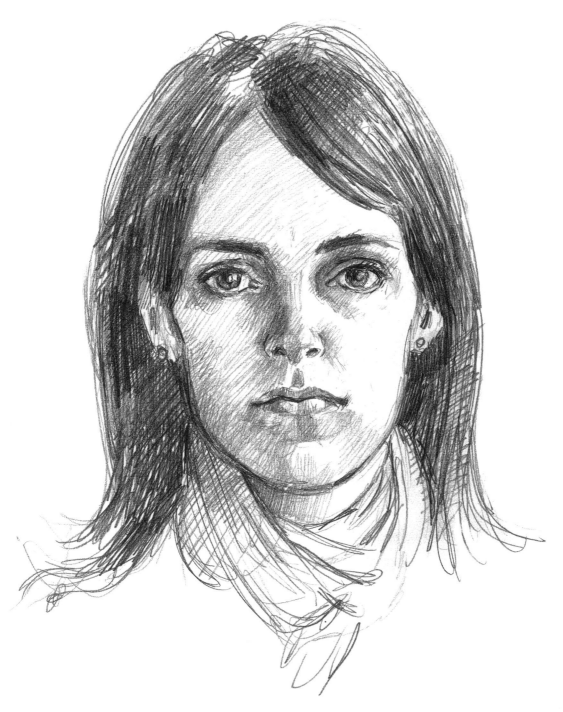

Step 5

In the last stage, draw in the very darkest tones and the variety of tones over the whole head. You may have to darken the hair quite a bit, but remember that only the deepest shadows should be black.

Mark in the edges of the eyelids carefully. The edge of the upper lid is much darker than the lower, partly because it is facing downwards and partly because the eyelashes cast a shadow. The pupil of the eye is dark, but usually you can see a bright speck which reflects the light in the room, which gives the eye its sparkle. Note the shadow around the eye near to the nose.

The shading around the nose and the mouth should be done very carefully – if you make it too dark the result will look a bit cartoonish. Try to let the tones melt into each other so that there are no sudden changes. The shading on the sides of the jawline are often darker than on the point of the jaw because the light is reflected back up under the chin. Keep stopping to look at the whole picture to see if you are getting the balance of tone right. Don't be afraid of erasing over and over again to get the right effect – the result may end up a bit messy, but you will have learnt a valuable lesson about form in a drawing.

SHOWING MATERIALITY

As you become more proficient, you will find that the marks you make when you draw any object give an effect of the material that it is made of. On these pages there are two examples to help you to explore this. The first is an exercise often given to art students to test their ability to observe shape and texture, and that is to take a piece of paper, crumple it up, and then put it down and draw it as accurately as you can. The second exercise is to draw a piece of woollen, cotton or silk clothing, showing its texture clearly. When you have finished these exercises you will have managed to draw many very different objects and you will know how to tackle a range of shapes and surfaces in the future.

Exercise 1

Start by drawing the crumpled paper in outline so that you have got the whole shape down. Keep the line light and as smooth as you can. When you think your drawing is close enough to the shape in front of you, make any corrections you need to.

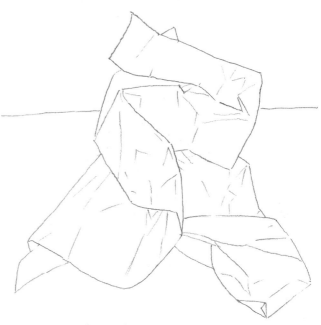

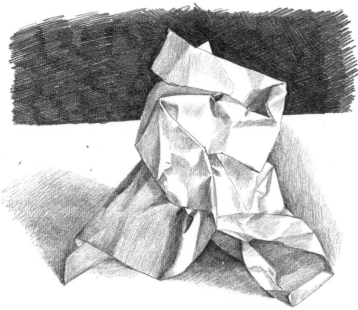

Now carefully put in as much of the tonal areas as you can – it is a bit difficult with white paper, because some of the tones are so similar. When all the tones on the paper are done, put in the background tones. As you can see in my example, the wall behind is quite dark, but the paper is resting on a white surface. The dark wall helps to throw the mass of paper forward in space a little, and gives contrast to the rest of the tonal areas.

Exercise 2

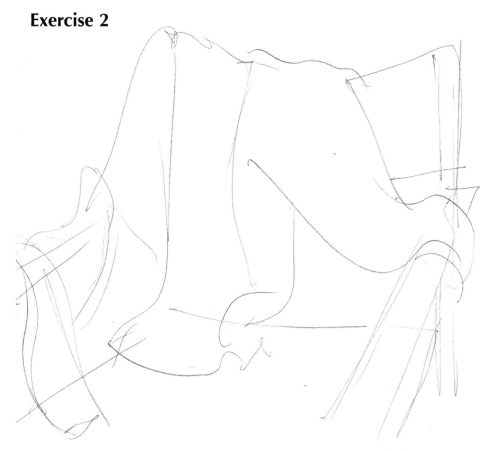

Step 1

For the piece of clothing, try this knitted cotton sweater draped across the back of a wood and canvas chair. First draw a rough sketch to make sure you have got the mass and bulk of the subject right.

Step 2

Now make a careful outline drawing, allowing the lines to suggest the soft edges of the material as well as the shape of it. Make sure that the hard, smooth lines of the chair contrast with the texture of the sweater's outline.

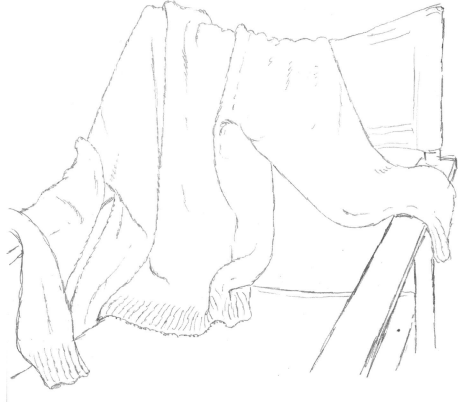

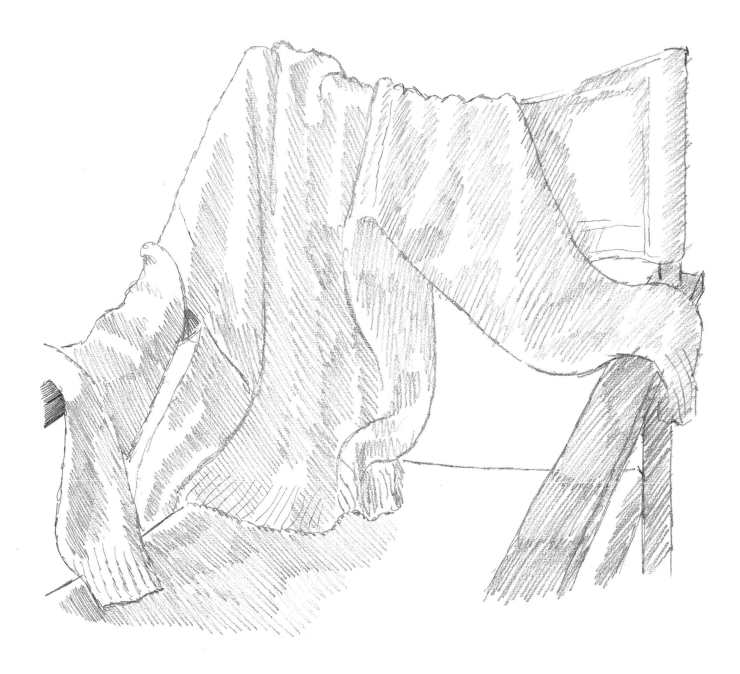

Step 3

Next make a careful all-over rendering of the main tone, not differentiating between dark and light tones at this stage.

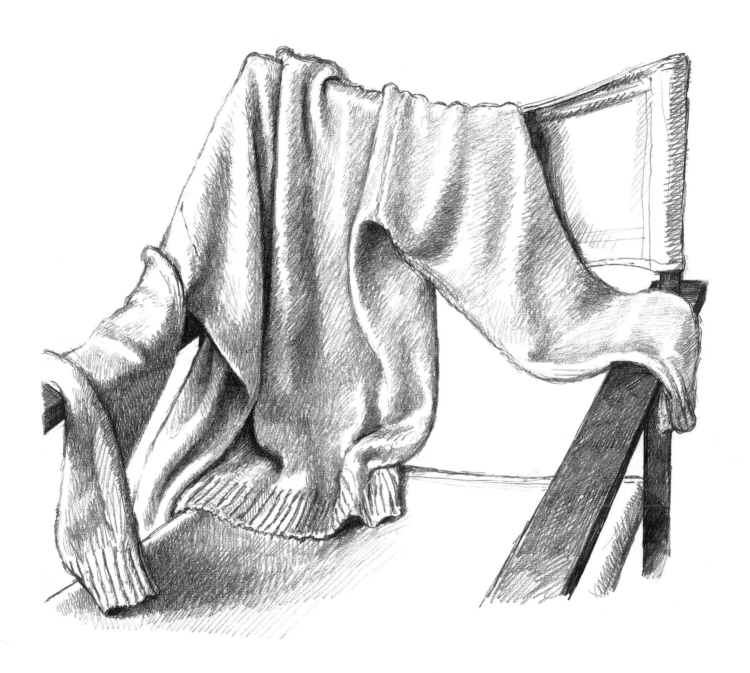

Step 4

Lastly, build up the tonal values to give an effect of the texture and soft drape of the garment, taking care to make the chair look harder and sharper-edged than the cloth.

DRAWING NEGATIVE SHAPES

So far, when you have drawn a subject you have no doubt been concentrating on trying to reproduce its shapes without giving any thought to what happens between them. In other words, you have been drawing only its positive shapes. However, those shapes between, known as negative shapes, are equally important in your work.

To learn how to handle these, first have a go at drawing a chair as I have done here, constructing its form so that it's clear where the back and the ends of the arms and legs form a complete cuboid shape, with the legs convincingly on the floor and the armrests both of similar length.

Now look at it in a different way. Staying in the same position relative to the chair, fill in all the spaces between the legs, rungs, arms and back so that you end up with a chair shape that is like a negative photograph. It's not easy at first, but if you observe all these shapes very carefully you will achieve a drawing that starts to look like a chair. This exercise is very valuable to you as an artist because it makes you look at everything when you draw a subject, including all the apparent spaces around it, which are just as much of what you see as the solid objects that make up the scene. It is also much easier to measure size and proportion when you include all the bits you don't usually draw. When you carry out this exercise you are practising seeing like an artist, not just your handling of your medium.

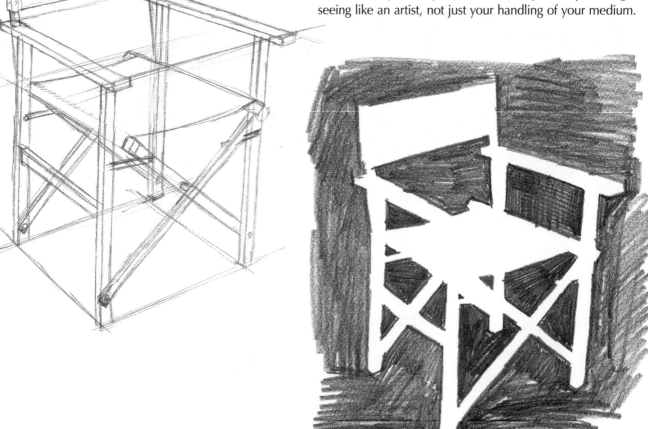

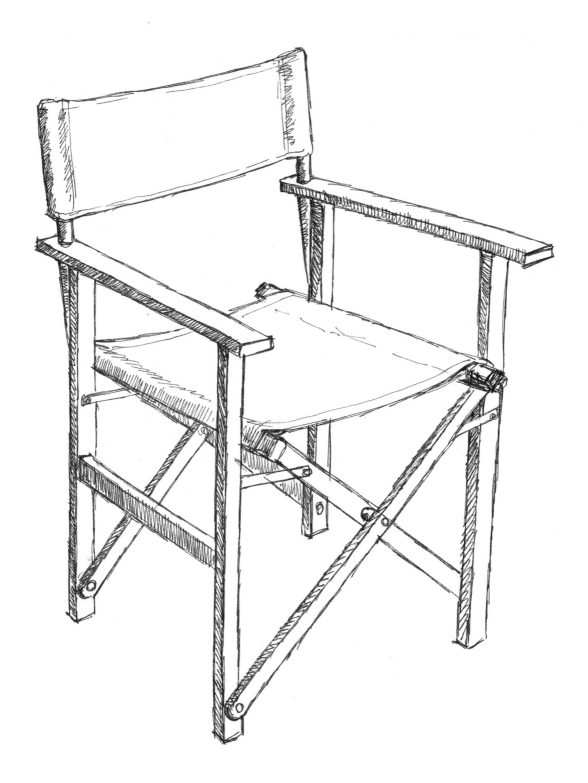

Finally do a straight observational drawing in either pencil or pen, getting everything in the right place and in the correct proportion. Try to be as accurate as you can, without actually measuring.

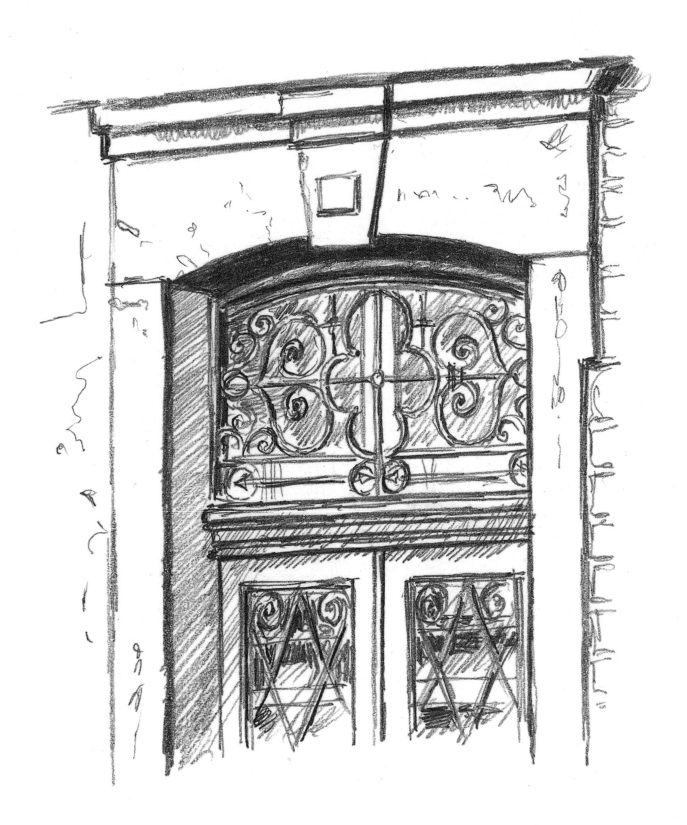

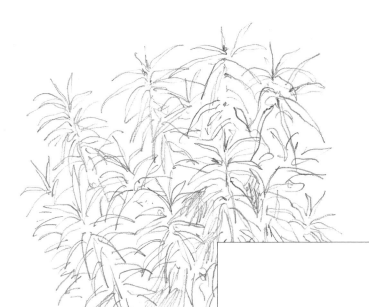

Lesson 3

THE OUTSIDE WORLD

In this lesson the emphasis is on going out of your house to explore the surrounding landscape as a subject. While drawing landscapes is not much different in essence from drawing anything else, the sheer scale of the view is sometimes a bit daunting, so you will need to find ways of tackling that.

The lesson is quite short in comparison to some of the others, but it will take you longer to work through because of the nature of the subject matter. This is also the lesson where you first begin to place objects in the larger scheme of things and start to understand how a whole scene can be handled.

One thing that you may find difficult is that when you are drawing in public places, someone will almost certainly want to see what you are doing. In the main I find that people are quite polite about this, but if you find the attention unnerving, remember that it's of no consequence what anyone thinks of your work except you. So steel yourself to disregard any uncomplimentary or jocular remarks – what matters is that you keep drawing.

WATER AND PLANTS: PRACTICE

Finding a path into drawing a whole landscape is made so much easier by looking closely at its fundamental parts and realizing that a pebble, a rock and a mountain are effectively the same forms on a different scale, just as a leaf and stalk on a houseplant are a miniature version of a tree and a puddle is a tiny lake.

Make an easy start by dropping a little water on to a flat, plain surface that won't absorb the moisture – I used my kitchen worktop. What you will then have is a very small pool of water that reflects the light. Draw carefully around the outline shape, then put in any tone that you can see, shading it with your pencil. It will probably be quite simple, as you can see that my puddle was. There were a few tiny outer splashes of water as well, which I put in – adding any extra details like this will help you to get the feel of water and its properties.

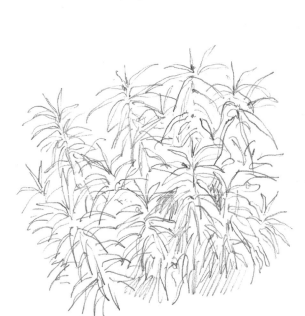

Now draw some plants to get a clear idea of how they work visually. I have drawn just two bunches of leaves that were growing in my road – I could have drawn much more from what was there, but this was quite good enough to get my hand in for drawing vegetation. You will have to decide how much you need to draw in order to feel confident.

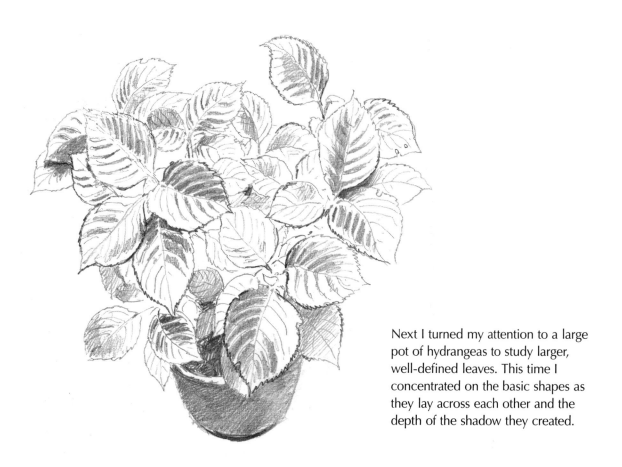

Next I turned my attention to a large pot of hydrangeas to study larger, well-defined leaves. This time I concentrated on the basic shapes as they lay across each other and the depth of the shadow they created.

A fig tree provided a good example of massed leaf forms that give a general idea of how vegetation can look as part of a larger landscape.

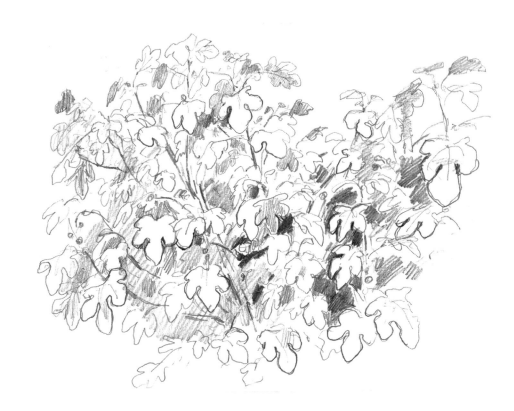

A SCENE CLOSE TO HOME

Now I want you to tackle a landscape drawing that can be done close to where you live. Pick a nice day when you won't have to be struggling with the wind or trying to protect your drawing from the rain – the idea is to make things as easy as possible for yourself on your first attempt to draw a real landscape.

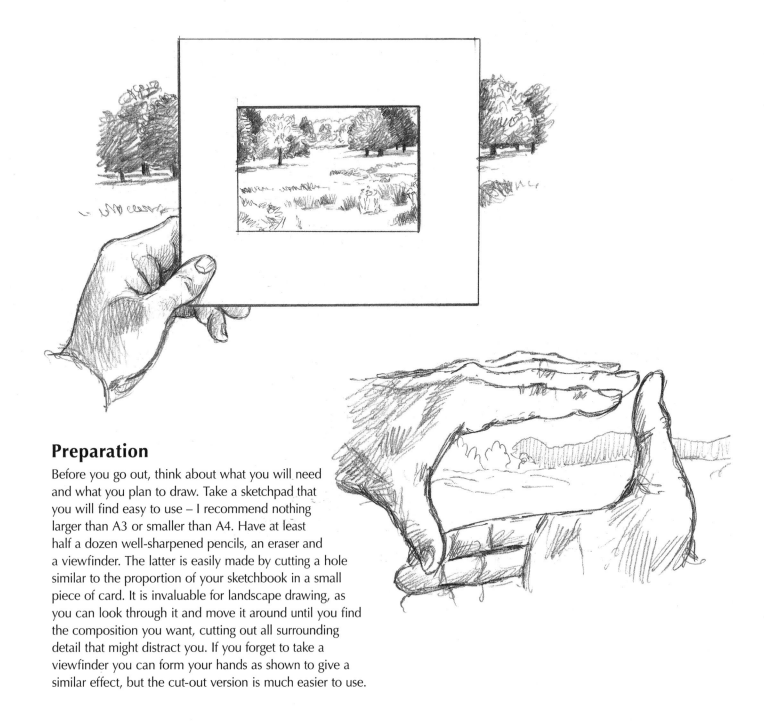

Preparation

Before you go out, think about what you will need and what you plan to draw. Take a sketchpad that you will find easy to use – I recommend nothing larger than A3 or smaller than A4. Have at least half a dozen well-sharpened pencils, an eraser and a viewfinder. The latter is easily made by cutting a hole similar to the proportion of your sketchbook in a small piece of card. It is invaluable for landscape drawing, as you can look through it and move it around until you find the composition you want, cutting out all surrounding detail that might distract you. If you forget to take a viewfinder you can form your hands as shown to give a similar effect, but the cut-out version is much easier to use.

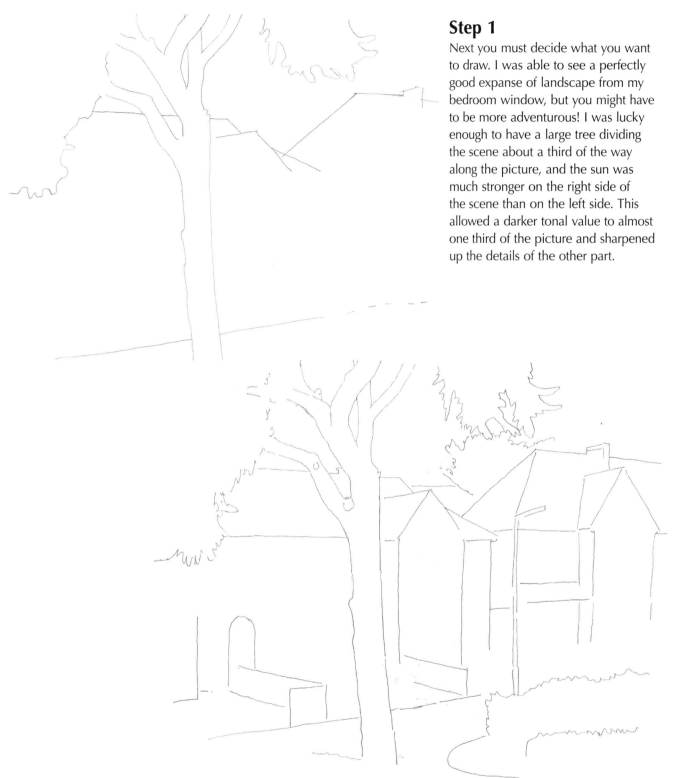

Step 1

Next you must decide what you want to draw. I was able to see a perfectly good expanse of landscape from my bedroom window, but you might have to be more adventurous! I was lucky enough to have a large tree dividing the scene about a third of the way along the picture, and the sun was much stronger on the right side of the scene than on the left side. This allowed a darker tonal value to almost one third of the picture and sharpened up the details of the other part.

Step 2

I drew the tree shape first and then the line of the rooftops afterwards. I worked over the left side of the drawing first and then concentrated on the details of the right side. This enabled me to decide just how dark the darker tones were going to be to create the right balance of interest.

Take your time on your own drawing, because the care and attention you give it are all part of working your way towards being an accomplished artist.

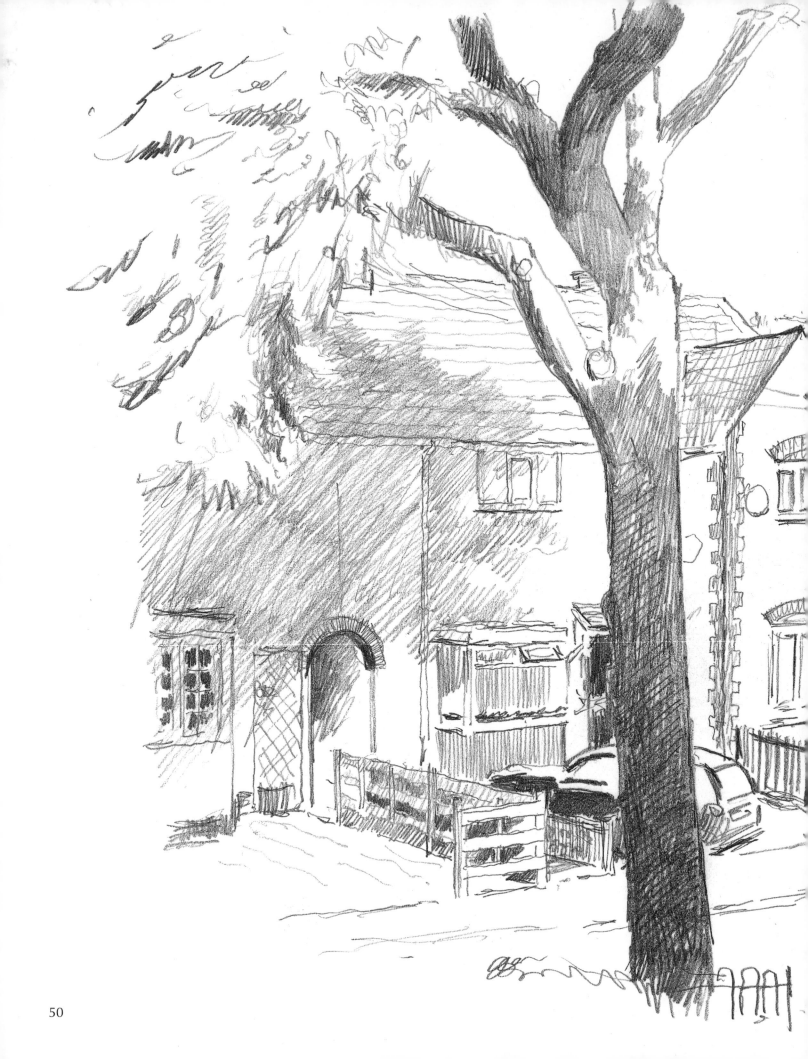

50

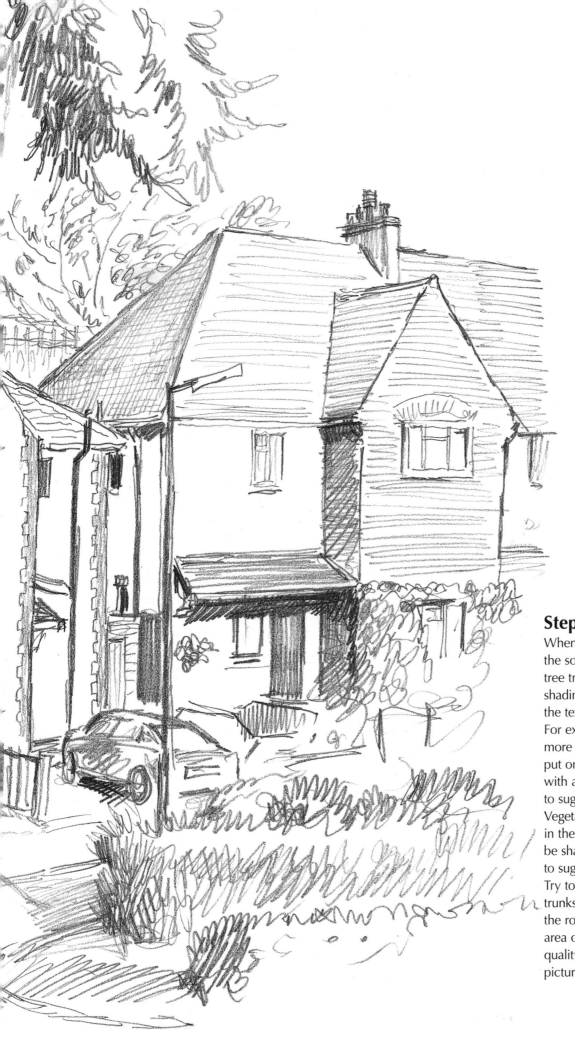

Step 3

When you come to describe the solidity of buildings and tree trunks, you can use your shading techniques to explain the textural qualities as well. For example, roof tiles will look more convincing if your tone is put on with horizontal strokes, with a slight undulation to them to suggest the ridges of the tiles. Vegetation such as the hedge in the front of my drawing can be shaded with scribbly marks to suggest the myriad leaf-tips. Try to make the marks on tree trunks a bit broken to suggest the roughness of the bark. Each area of shading can reinforce the quality of the elements in the picture in this way.

AN URBAN SCENE

An urban scene can be just as picturesque and interesting as the countryside. For a start, draw urban details that are easy for you to see, just as you drew individual patches of water and vegetation before embarking on your first landscape.

Preliminary drawings

I have made a selection of the upper parts of a doorway with ironwork protecting and decorating it, a set of chimneypots, and finally a roof eave with a window and drainpipes. However, you don't have to limit yourself to buildings – anything that takes your attention as you are wandering about is fair game, even if it is just a dustbin by a gate or a garden fence. You can find inspiration and interest everywhere if you look with an inquisitive eye.

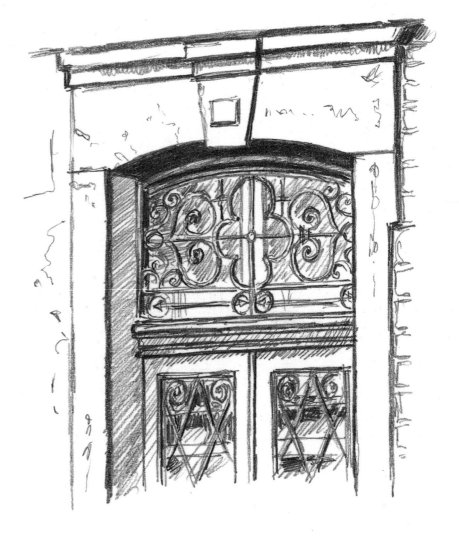

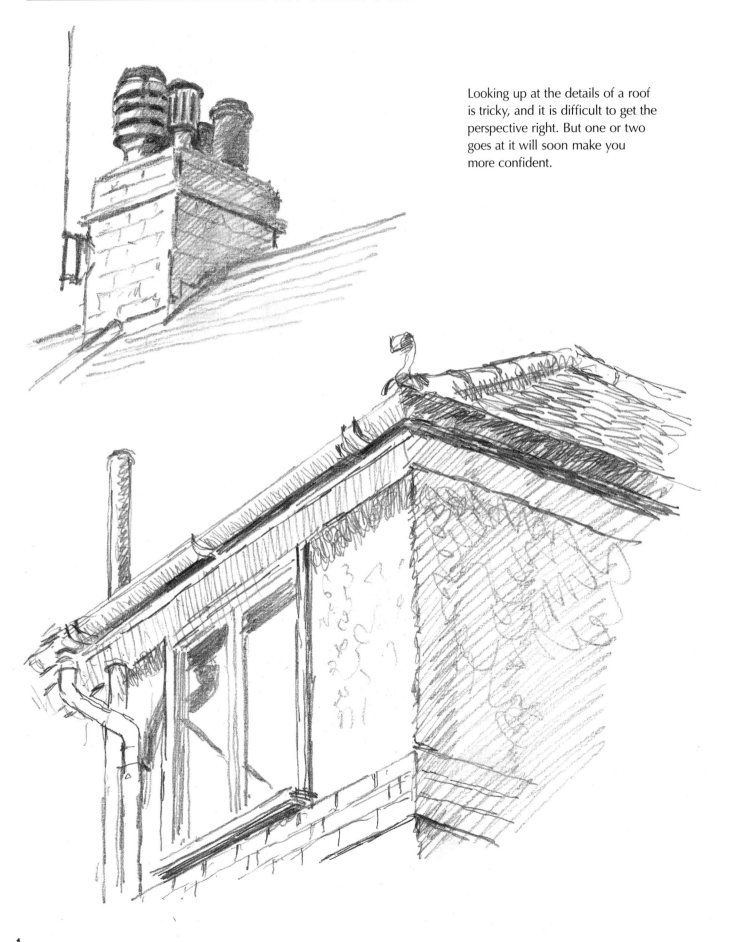

Looking up at the details of a roof is tricky, and it is difficult to get the perspective right. But one or two goes at it will soon make you more confident.

Once you've spent some time accustoming yourself to urban details, you will probably decide you want to have a go at a typical urban scene. I went to central London on an autumn day and took up a viewpoint at the end of a short street in Soho with shops and restaurants on each side.

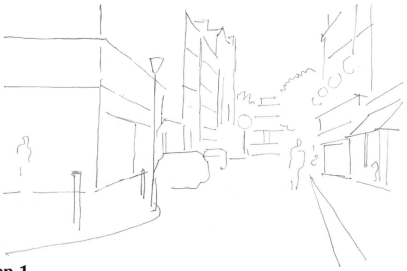

Step 1

First I sketched in the main shapes of the street, indicating parked cars and one or two figures. The same figures wouldn't be there when I finished, but there would be others that I could impose on the same spot.

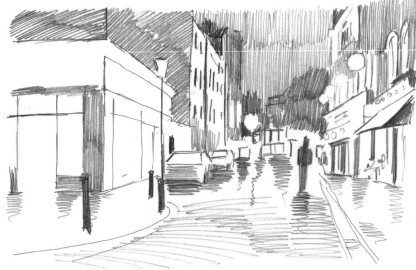

Step 2

During the time I was drawing the daylight started to fade and the streetlights came on, so I worked up the tonal differences between the illuminated shop windows and streetlights and the dark masses of buildings and trees in the distance. Darkening the sky made the lights appear that much brighter in contrast. I included the tones of the reflections on the damp pavements.

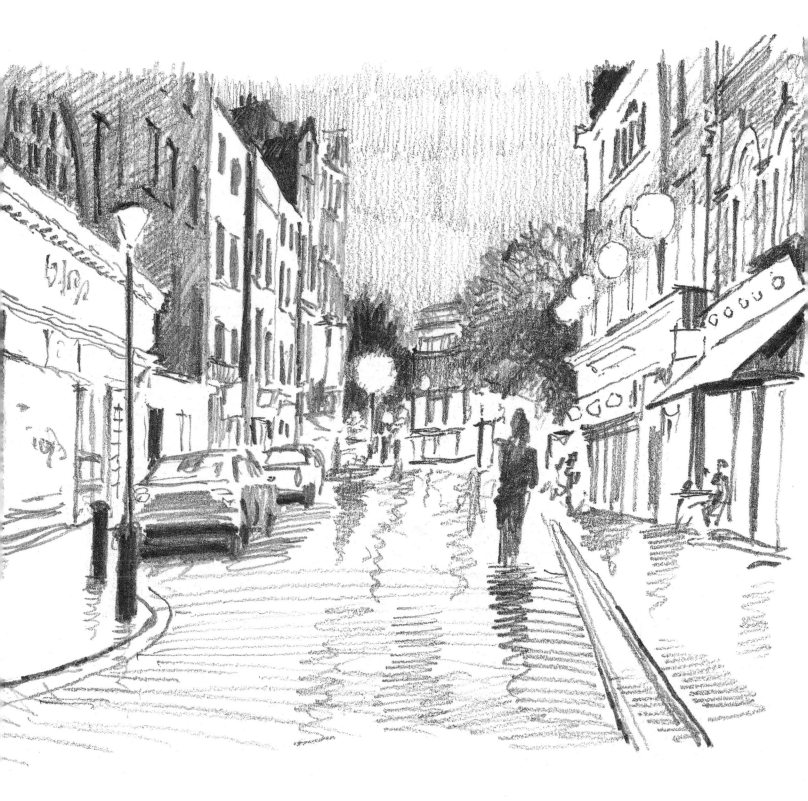

Step 3

Having built up the main areas, I could now work more subtly to bring out the atmosphere of the street at night. Notice how the details of the windows in the buildings become mere dark marks along the receding façades of the houses. Finally, I put in the very darkest tones to sharpen up the whole scene.

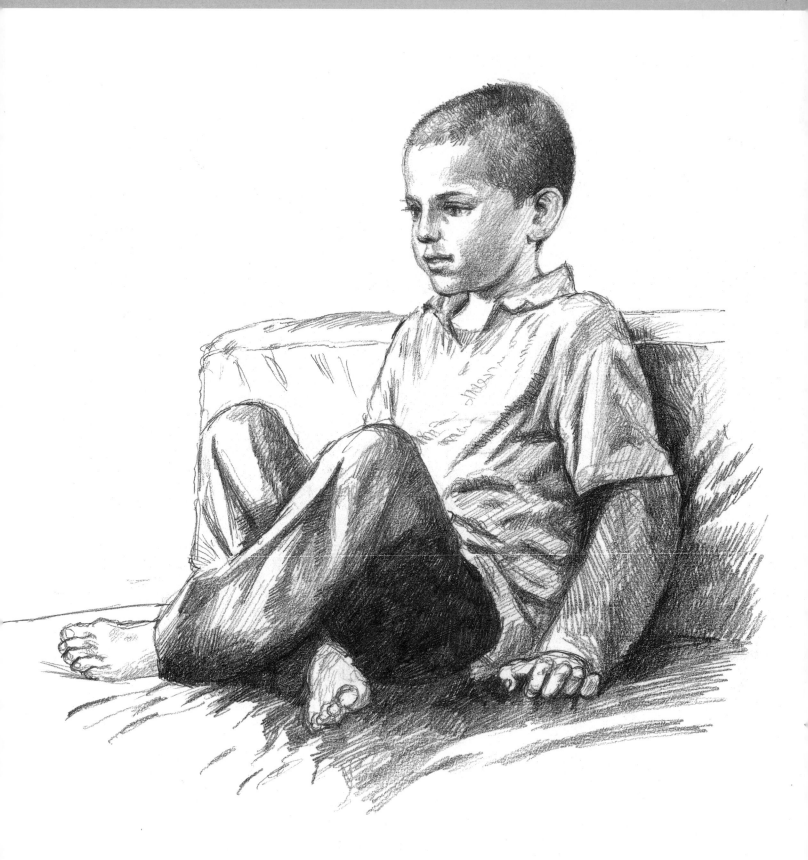

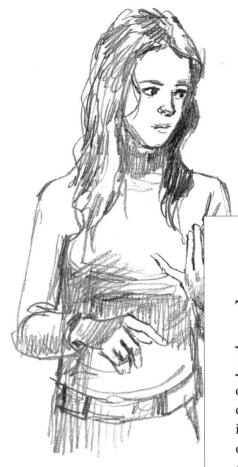

Lesson 4

THE HUMAN FIGURE

In this lesson we come to one of the most interesting, most subtle and most taxing of our drawing challenges. The human figure is the one subject that we all think we know about, because we are humans ourselves. However, because of our close connection with the subject, it's easier not only to follow our preconceptions rather than relying on observation, but also then to realize we have got things wrong. It's consequently rather more difficult to satisfy our own demands of our skill, but that's not a bad thing because it pushes us to strive harder to achieve what we want.

There are many approaches to this field of drawing, and I have tried to include all the obvious ones. Eventually you will learn many more ways to draw the figure, but you have to start with a method that is easy to understand and achieve. You will see how to simplify your drawing and to get the main movement through the shape of the figure, and we will also look at some details, including the figure in perspective and how to analyse the shape.

Finally, of course, it will be your own observation that will increase your drawing skill in this subject, as in others. You will need the co-operation of your friends and family in this series of exercises, but you will find that most people are happy to oblige, especially if you can be expected to do a really good drawing of them.

THE PROPORTIONS OF THE HUMAN FIGURE

Obviously people vary in their exact proportions, but using the head as the basic unit, the average man or woman, fully grown, is about 7½ to 7¾ heads tall. However, most drawings and paintings of human beings can be drawn simply as if 8 units made up the height. This would probably be true of a tall person and so is not too out of proportion – in fact it was the measure generally used for beautiful or heroic figures in art history, so you will not find your models complaining! It is certainly an easier proportion to draw than 7½ units.

The male and female figures hardly differ at all in their height proportions, but there is a difference in width; the male figure is wider at the shoulders, the female wider at the hips.

Male figure: front view

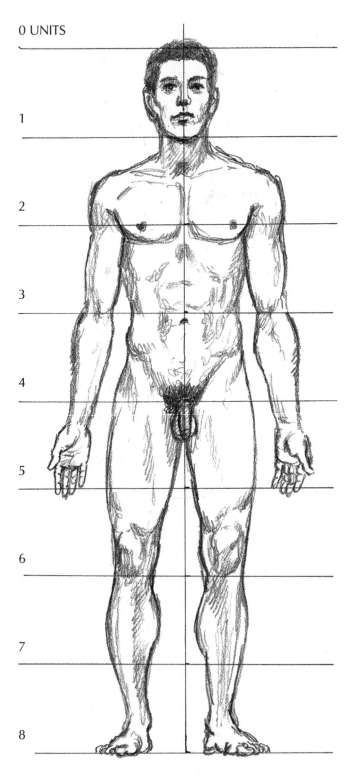

0 UNITS

1

2

3

4

5

6

7

8

Female figure: side view

0 UNITS

1

2

3

4

5

6

7

8

Child (9–10 years old): front view

A child's head is much bigger in proportion to the body. At one year old it is about 3 to 1 and as the child grows the proportions gradually approach those of an adult. At about 9 or 10 years old, a child will be about 6 units or heads to the full height.

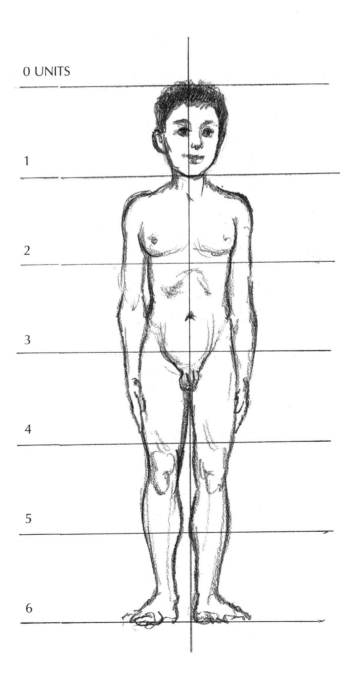

0 UNITS

1

2

3

4

5

6

DRAWING SIMPLE FIGURES

For looking at the human figure more extensively, you will find that a good supply of photographs of people in action can be very useful. While the best drawings are done only from life, using photographs, especially if you have taken them yourself, is not a bad substitute.

First of all, limit yourself strictly to the simplest way of showing the figure, which is almost like a blocked shape with a line through its length. In these figures the movement is not great, as befits a first attempt, and two of them were taken from photographs. Simplify all the time when drawing figures because the movement is so difficult to catch that you don't have time for details. Try to do a few drawings like this, spending just 3–4 minutes on each one and making your lines fluid and instantaneous, even if at first the results look terrible. All artists start like that, and only time and repeated practice effect a change.

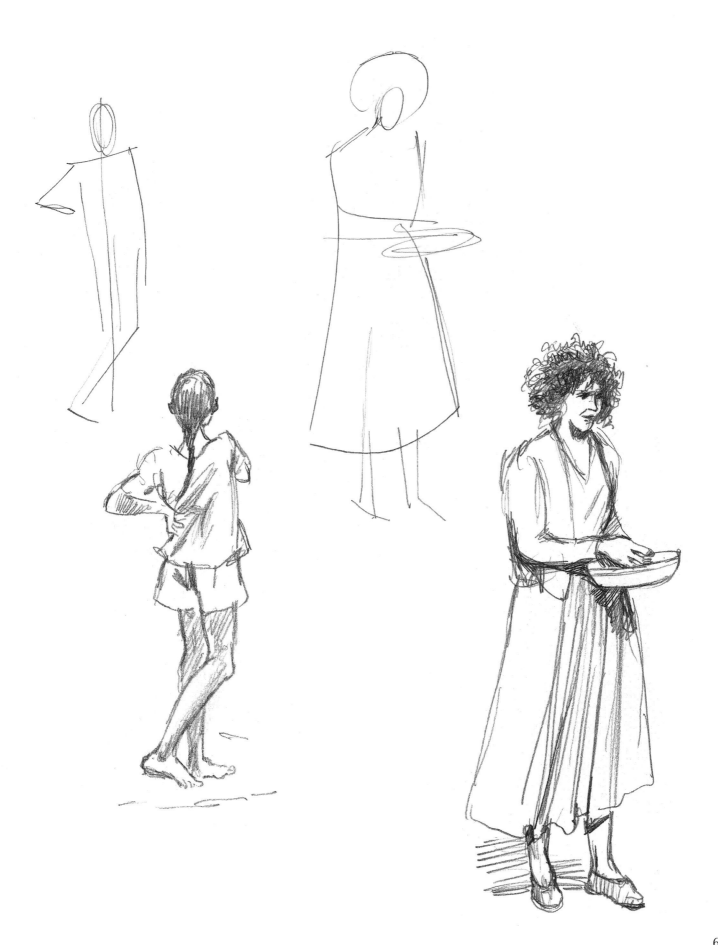

Line of movement

In the drawings on this page I have used the stick drawing technique, drawing only the line through the movement of the shape first, in order to get the feel of the flexibility of the human form.

Have a go at this first before you draw the figure more solidly, keeping the stick drawings at the side of your more considered drawings to guide you. Put in the figures as simply as you can, leaving out all details and limiting yourself to about 10 minutes per drawing.

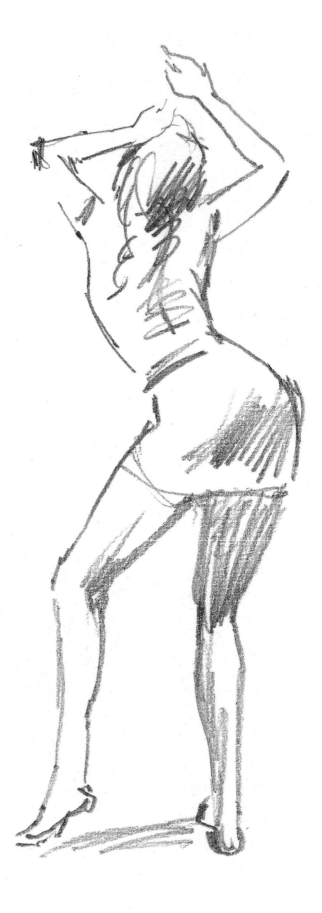

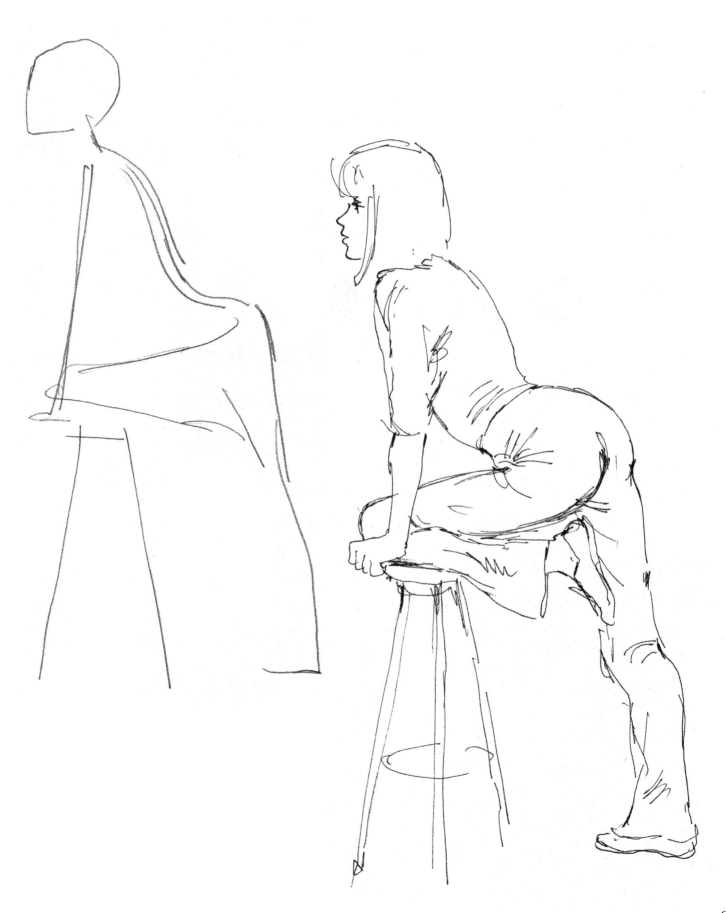

Blocking in figures

The next four drawings are approached in a slightly different way from those on the previous pages, because I have blocked in the main shape rather than taking a line through the movement. This makes me look at them in a slightly different way, because now I am concentrating on the solidity of the shapes. It helps that these people are in more settled positions, so there is more time to draw them.

Once again there is no detail at all in these drawings – even the features are mere dashes of pencil to indicate their position rather than their shape. Make your own drawings of figures in more reposeful positions than you have tried so far.

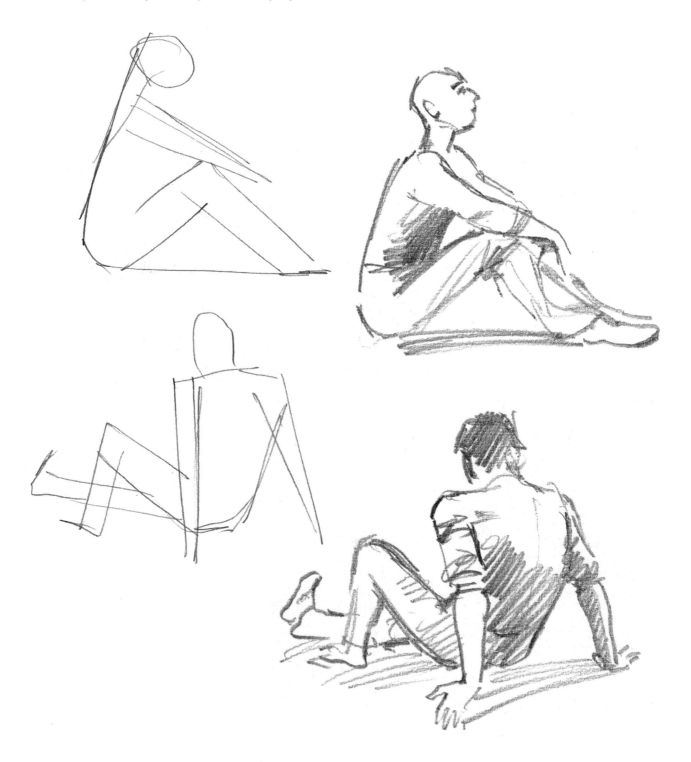

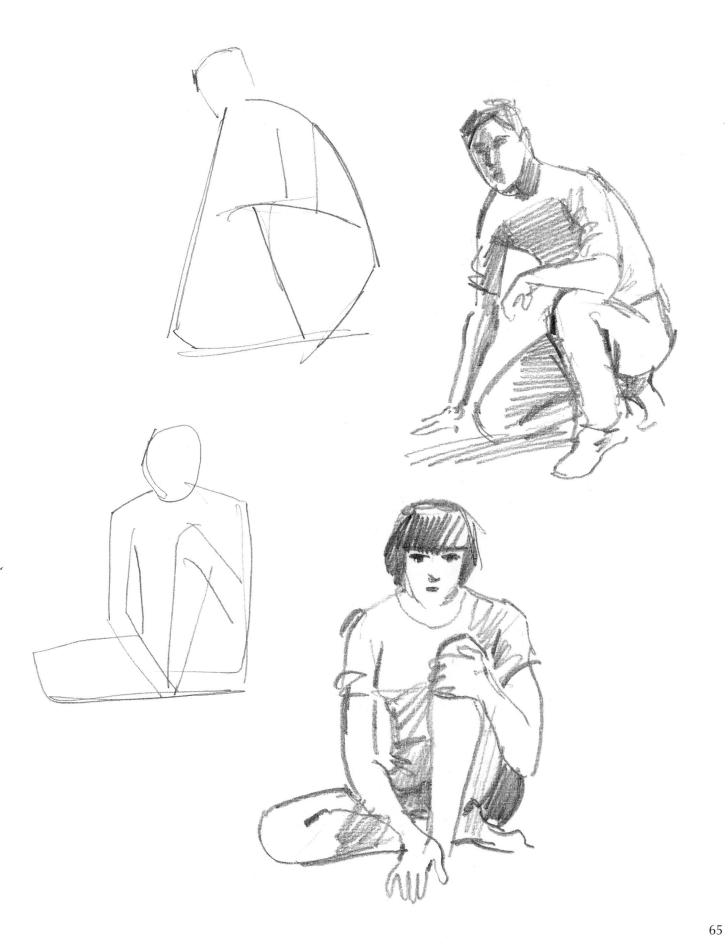

EXPRESSIVE FIGURES

Here we are still looking at the human form, but in poses that are less formal and more expressive. The four figures on this spread are not even shown in full, because my interest is in the gesticulating hands. Once again these might be easier for you to draw from photographs that have frozen the moment.

Block these in to start with as you did before, but pay particular attention to the position of the hands. One girl looks as if she is ticking off points on her fingers, one man is gesturing to draw attention to something, the other girl is in the process of combing her hair and the last man is sitting down to draw something . . . perhaps you!

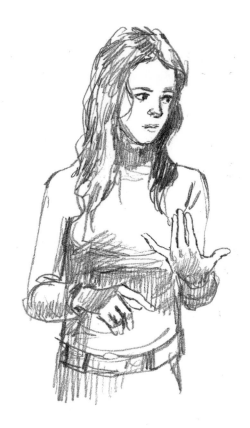

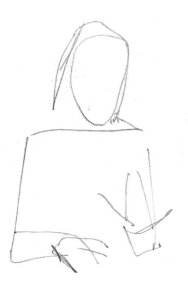

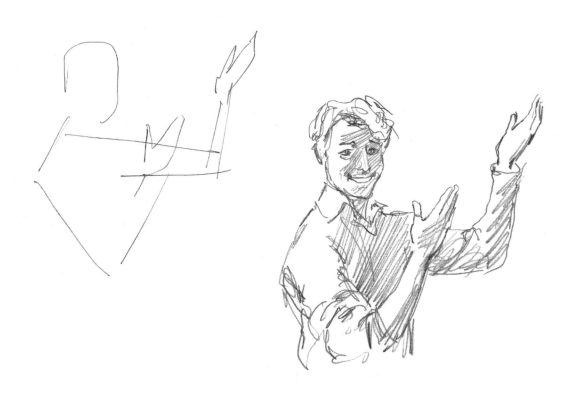

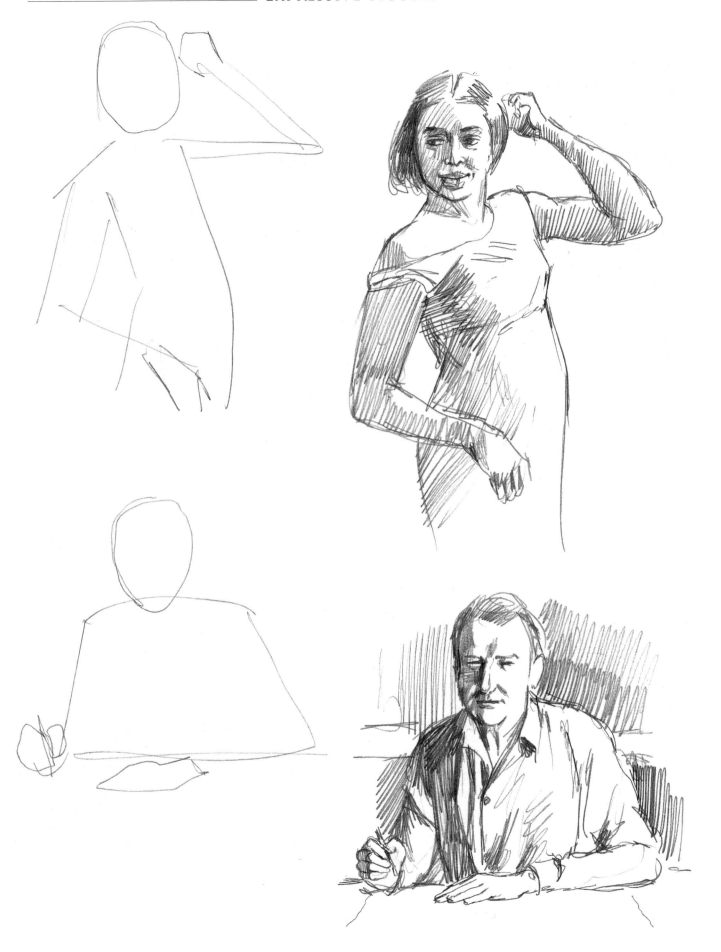

FORESHORTENED FIGURES

The next drawings look at figures which are lying and sitting in such a way that some of their limbs are foreshortened, making your task more difficult. You will have to look carefully at how the proportions of the limbs differ from how they would appear if the same figures were standing up.

We have three male figures in poses where the foreshortening of the limbs needs to be noticed as you draw them. When you ask your friends or family to pose for you, make sure that sometimes they sit with their limbs advancing or receding to create this opportunity for you to draw in perspective.

The first figure, sitting on a stool, is relatively straightforward where the legs are concerned, but the folded arms pose a foreshortening problem.

The second man is seen almost from above, so that the arm he is resting on half disappears, and one bent lower-

leg is almost hidden from our sight.

The last figure of a kneeling man poses problems with both the arms and the legs, so observe them carefully if you try this pose. While these drawings are all more useful if done from real people posing for you, if you can't get enough models, use photographs – but take them yourself. As before, don't forget to block in the pose before you try to put in all the details.

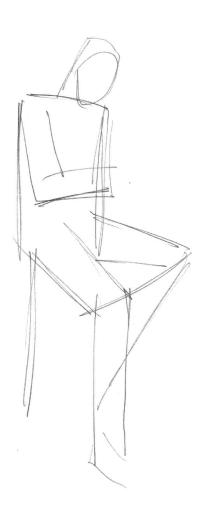

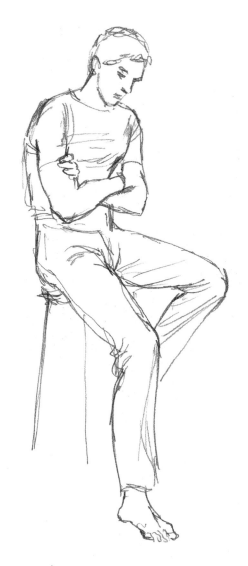

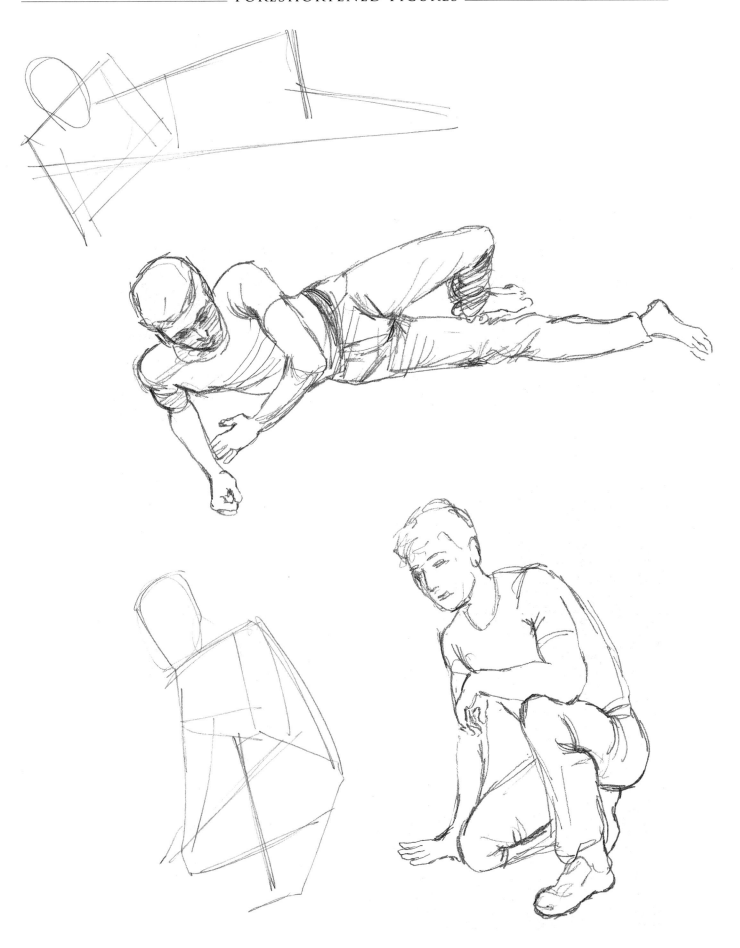

THE LIMBS AND EXTREMITIES

On these pages, we'll look at the limbs, hands and feet in more detail. You won't necessarily draw all these particular poses, but try as many as you can before moving on to the next stage. Again it is of more benefit if you can draw from life, and in most cases you could use yourself as the model with the use of a large mirror.

Arms and hands

First, draw some arms from different angles. Those that I've drawn are both feminine and masculine, but if you are drawing your own arms, that doesn't matter at the moment; male and female arms look different, but the basic anatomy is the same.

In my drawings I've shown both the use of tone and a more linear approach to define the form. No matter how many arms you draw, there will always be more to discover about their formation in different positions. If you become really interested in the construction of the human body, you'll find that a good book on anatomy for artists is invaluable.

The hand is a study in itself. Tracing round your own hand will remind you of its basic shape.

Legs and feet

To draw the legs and feet, again you can use your own seen in a mirror or ask people to pose for you. You will need to show the difference between female and male legs, which is evident in the softer, rounder forms of the former and the harder lines of the latter. However, the difference may not be so obvious on the legs of a female athlete compared to the legs of a sedentary male. The hardest part is to get the proportion between the upper and lower leg correct, and the drawings of the knee and ankle joints.

Draw the legs from various angles: front, back, side and crossed over each other. This helps you to see how the various groups of muscles behave from different angles. When the legs are under more tension the muscles will appear more prominent. The knee joint and the area where the foot joins the leg are quite tricky to get right and it is worth making several studies of them.

Feet are not too difficult in themselves, being less flexible than hands, but the difficult angles are drawing them from directly in front or from the rear.

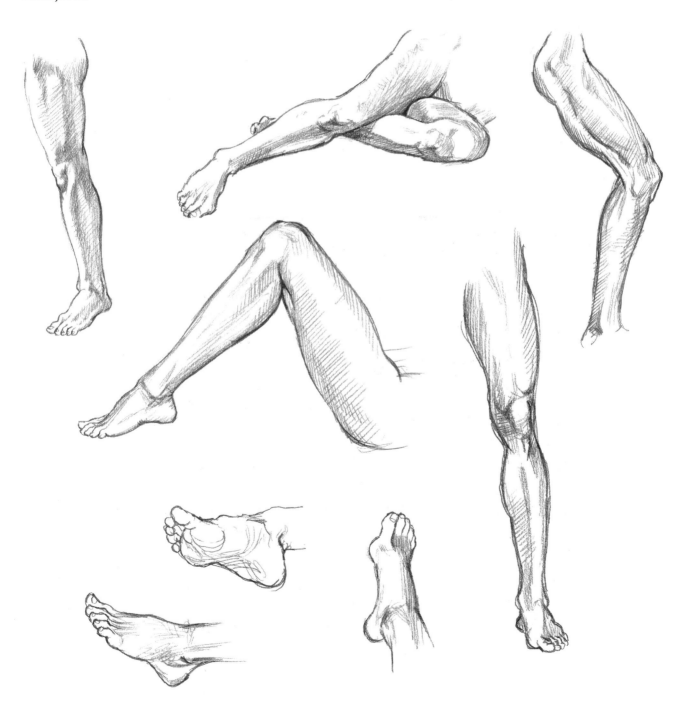

THE HEAD: PRACTICE

The following exercise will be to draw a complete portrait of someone, and you need practice on the head to make a success of this. Here I have given you a drawing of the head both in profile and full face, with measurements to give you the basic proportions. Although my example is a female head, the same proportions apply to the male. Of course these are generalities, but the differences in proportion in individual heads are so small that it is a good basic set of measurements.

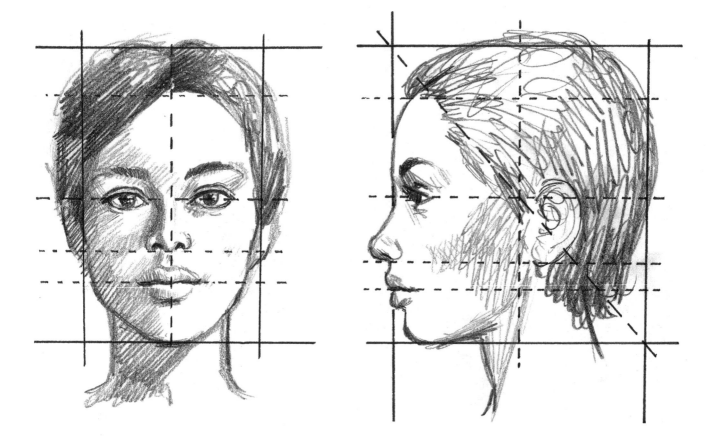

The full-face version shows that the head is longer vertically than horizontally. You can also see that the eyes are halfway down from the top of the head. The length of the nose is about half this again, but the mouth is closer to the nose than to the chin. The widest part of the head is just above the ears and the eyes are the same distance apart as the length of the eye from corner to corner.

On the profile drawing, the hairline is positioned at about half the area of the head on a diagonal basis. The shape of the head is about the same distance across horizontally as it is in length, ignoring the projection of the nose. The ear is just behind the halfway vertical. Note that the distances from the mouth to the chin and from the hairline to the top of the head are each about one fifth of the whole length of the head.

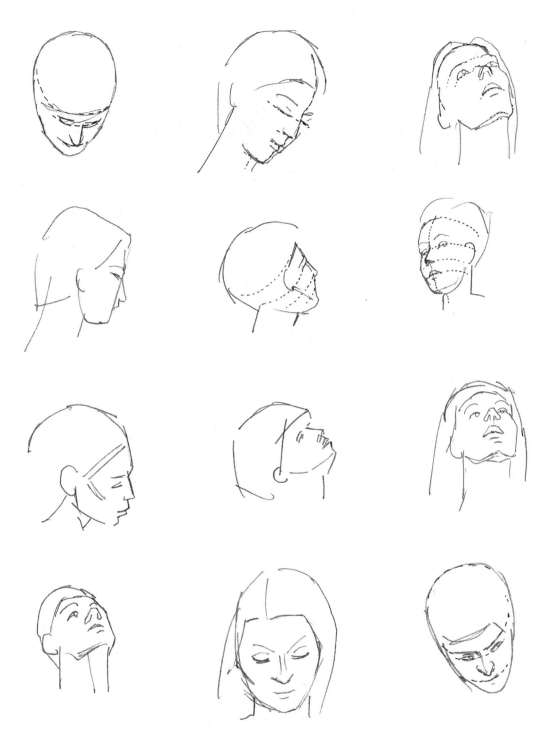

Now for a few examples of heads in different positions which you will need to study, because you won't necessarily find your subjects' heads in exactly the full-face or profile version. Some of these are seen from slightly below and some from slightly above. The former show the projection of the jaw and the nose seems to be shorter and almost blocking out some of the eye; the latter show more of the top of the head and the mouth tends to disappear under the projection of the nose.

These drawings are all done as blocked-out shapes, emphasizing the three-dimensional quality of the head and getting across the idea of the whole shape, not just the face. If you are a beginner this form of drawing is important for you because it makes you start to see the complete volume of the head, which few non-artists think about.

73

These drawings show other versions of heads in different positions, but this time with the hair and features put in more naturally. Draw as many different versions of heads as you can, because it will improve your ability to draw portraits in more depth. As before, try to do as many of them from life as possible, resorting to photographs you have taken yourself if need be. Notice how the shadows on the faces give an extra dimension, not only to the form but also to the expressions.

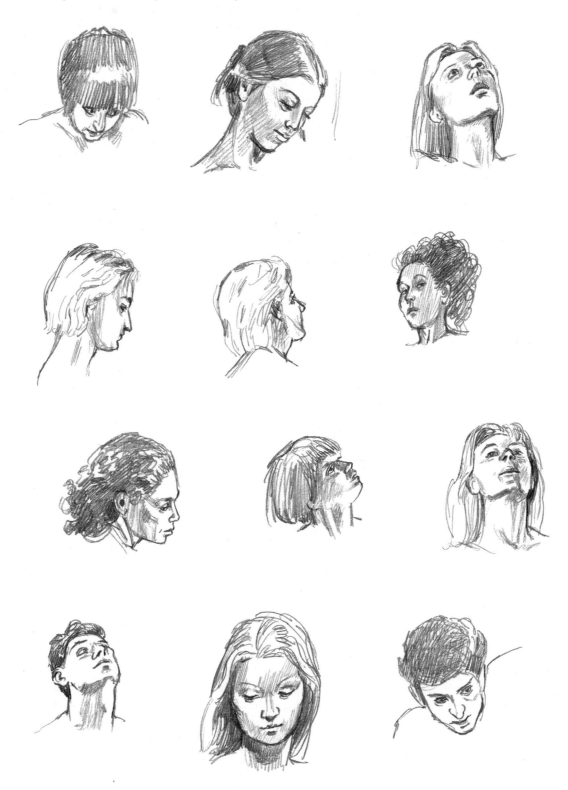

A FULL-FIGURE PORTRAIT

This exercise will seem like a reward for all your hard work so far on the human figure – drawing a complete portrait of someone who will be prepared to pose for you for a while. I took as my model my six-year-old grandson, who is not easy to keep in one position, but I put him in front of the television to watch a film that I knew would interest him so he sat for a little longer than usual. That in itself is a lesson – make your models comfortable and happy and you will get more time to draw them!

Step 1

At first you will need to draw the main shape of the figure. Keep it very simple to start with and use your eraser, correcting as much as you can at this stage – it saves time later on.

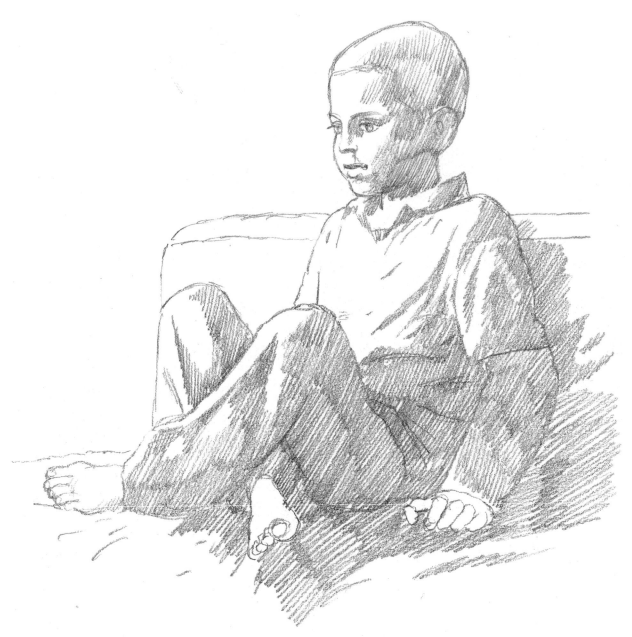

Step 2

The next stage is to put in all the shadows that seem relevant, again keeping everything simple – but it is at this stage that the face needs to become recognizable.

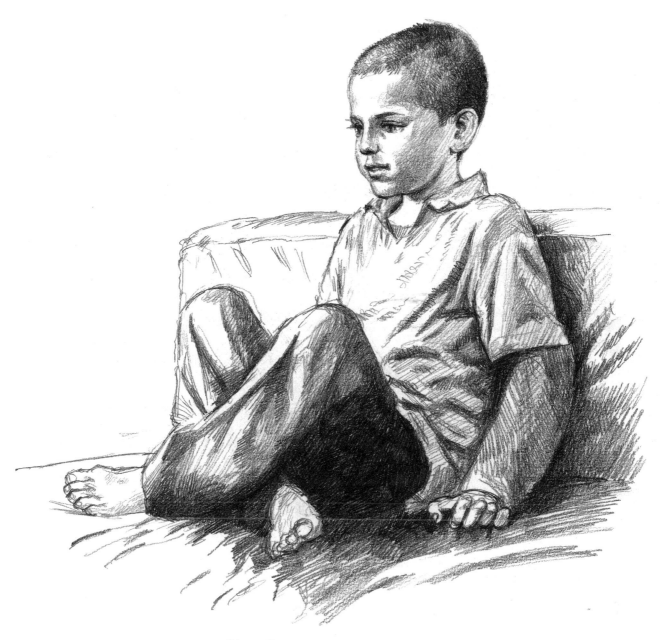

Step 3

Once you are sure everything is the right shape and in the correct proportion, begin to work into the picture to make it come to life. Take great care over the head, because this is where the picture becomes a portrait of a particular individual rather than of just anyone. This is not so difficult as it sounds because we all have this marvellous ability to recognize human faces, so you will automatically draw the features correctly if you really pay attention. Build up the tones in such a way as to stress the softness or hardness of the form.

Good luck in your efforts – even if you are not successful this time, the practice will enable you to do a lot better on the next occasion.

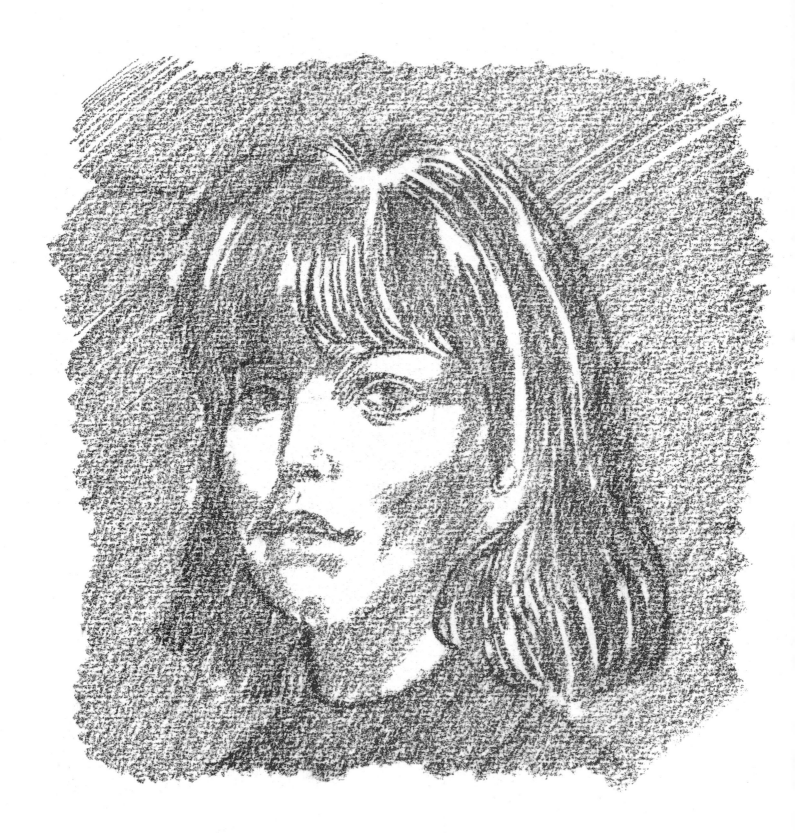

Lesson 5

OTHER MATERIALS

In this series of exercises you will start to try out different mediums available for drawing, all of them traditional. In each I have demonstrated the medium's uses, but I have by no means exhausted the possibilities. While every medium has a different influence on the method of drawing, when you have become more confident with them through constant practice you will find it interesting to overlap your techniques and tools in the spirit of ongoing experimentation.

What will eventually dictate your choice of medium for any particular picture is how well it suits the subject matter and the way you like to draw. Even when you have found one you especially enjoy working with, don't stop there – keep on trying out different methods and mediums to expand your repertoire and become fluent in any you favour. This is all part of the artist's technical trade, and although that may sound a bit mundane, in fact it is where the fun intermingles with all the hard work.

PASTELS

Pastel is a time-honoured medium in all its various guises, which include soft chalks and charcoal. The very softest pastels, which are usually rounded in section, are favoured by many artists, but they are expensive and are used up quite quickly. There are harder versions which are very good; these usually come in a rectangular section.

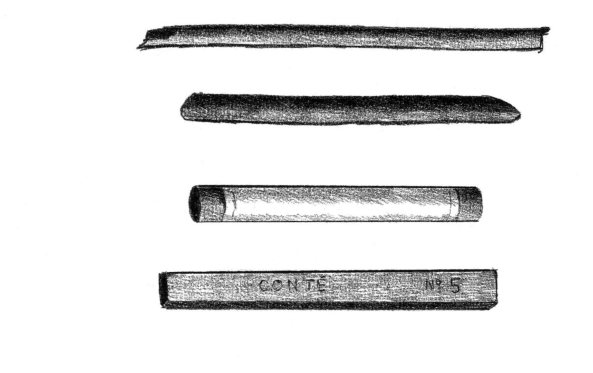

The type of charcoal most often used is known as willow charcoal, which has a very soft texture. This can be employed for any kind of drawing but tends to work best on a large scale. You can smudge it with your fingers or a tissue, or use a stump as with pencil drawing. Ideally, you should equip yourself with sticks of varying width and try them out first on a spare piece of paper as charcoal is quite crumbly if used too heavily – indeed, one of its great advantages is that it makes you handle your medium lightly. It can also cover the paper quickly and is quite easy to erase.

Conté is a form of compressed pastel or charcoal which is simple to use and doesn't crumble too easily. It has always been popular for drawing purposes. It also comes in a pencil form, sometimes called charcoal pencils. These are not quite so versatile as the stick form but are cleaner to handle.

Charcoal and pastel smudge easily, so you will need some good fixative to spray over your drawing after it is finished. This is available from art supplies shops.

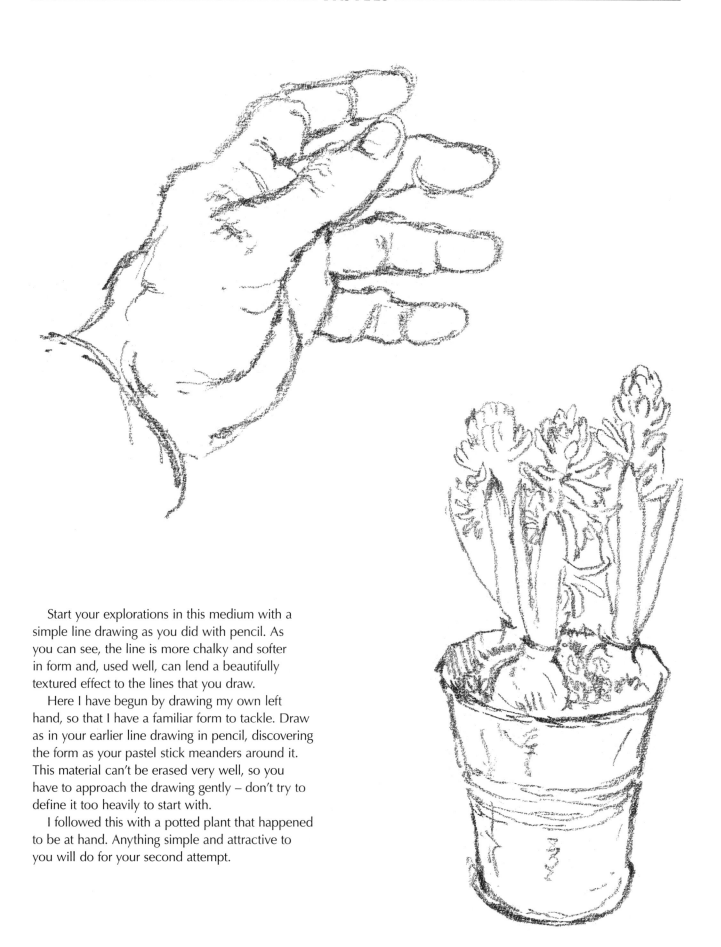

Start your explorations in this medium with a simple line drawing as you did with pencil. As you can see, the line is more chalky and softer in form and, used well, can lend a beautifully textured effect to the lines that you draw.

Here I have begun by drawing my own left hand, so that I have a familiar form to tackle. Draw as in your earlier line drawing in pencil, discovering the form as your pastel stick meanders around it. This material can't be erased very well, so you have to approach the drawing gently – don't try to define it too heavily to start with.

I followed this with a potted plant that happened to be at hand. Anything simple and attractive to you will do for your second attempt.

PASTEL: ADDING TONE

Exercise 1

To make the next stage easier, draw from a photograph rather than from a real person. Make sure the photograph is a good one with plenty of tone in it. One of the problems with using photographs for reference is that they never give you as much information as your eye gains from real life, but at this stage that's an advantage because it allows you to analyse the tones more easily.

Remembering that in this medium you cannot erase your lines much, draw in the main outline shapes of the face and head.

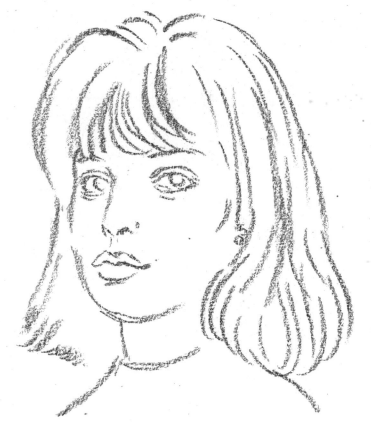

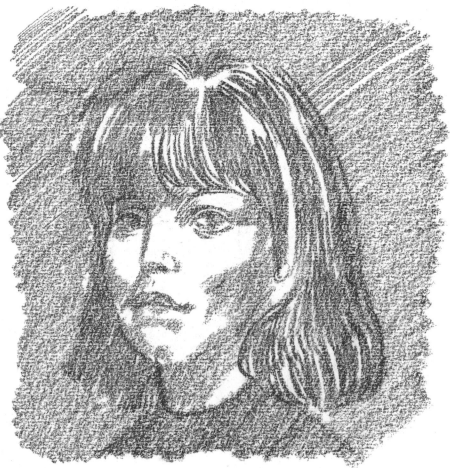

Then put a single tone across the whole picture where there is tone on the photograph, keeping it as light as possible.

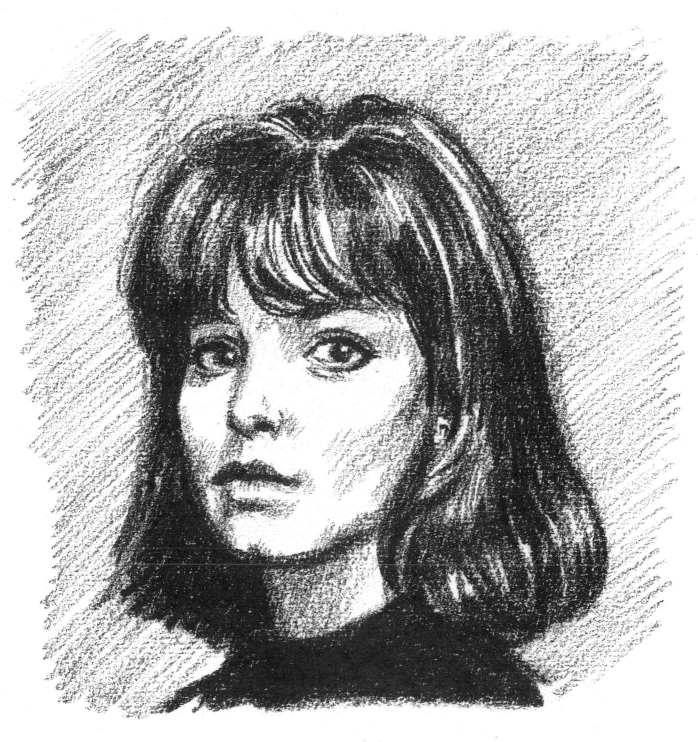

Lastly, build up the stronger tones so that the picture starts
to look like the photo you have been copying.

PEN AND INK

In this medium the line is paramount, and the tonal areas are built up with multiple lines or other marks. Because of this it is a slow medium for large drawings, but ideal for very small ones on account of the fineness of its marks.

There are many varieties of pen and ink to use, the traditional one being Indian ink applied with a dip pen. This ink is available in both permanent and watersoluble forms. I find the acrylic versions of it less good because they tend to gum up the pen nib rather rapidly. Indian ink is very black and definite, but the watersoluble type can be thinned to almost any degree of tone.

You will need to use a dip pen with a fine pointed nib designed for drawing, as opposed to calligraphy, for example. These can be bought in art supplies shops and other specialist outlets. The nibs come in several sizes and qualities of fineness, so you might have to experiment before you find the size you prefer. I always use the finest point I can obtain, but that's my preference. The flexibility of the nibs varies, which again is a matter of experimentation to find what suits you best.

There are also numerous graphic pens with their own ink supply and nibs in various grades of fineness. The one I use the most is the finest one, which is 0.1, but I sometimes also use grades 0.3, 0.5 and 0.8. Again you should try out different sizes to see which you prefer. The only drawback to these pens is that you have to throw them away when they run out of ink. A bottle of ink and a dip pen will last much longer and can be finer even than a 0.1.

For large areas of black you will need a large marker pen. These come in varying sizes and use the same sort of ink as the finer graphic pens.

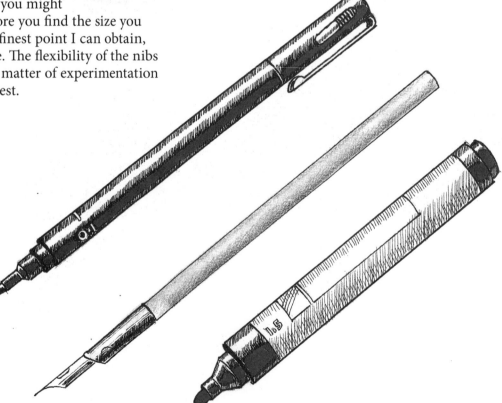

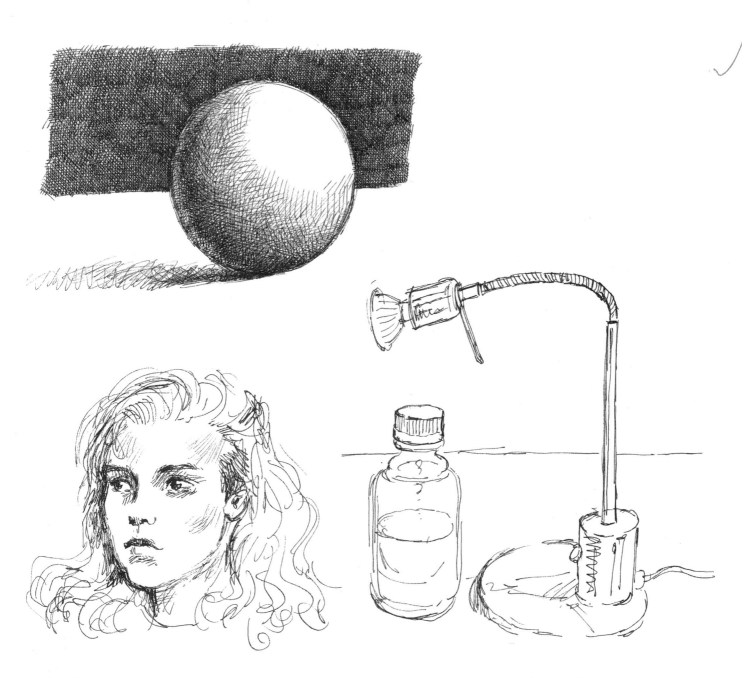

Now for some drawing. First try this sphere or ball, apparently sitting on a surface with a dark background. This was not drawn from life at the time but is a construct based on observation as to how light shows the shape of a spherical object. Notice how the texture of the tones is built up with numerous fine lines crossing over each other. This technique, called cross-hatching, can be controlled to show both light and dark tones – if you persevered you could ultimately achieve a solidly black surface.

The trick of this type of illusion is to space your lines carefully so that the difference between the darkest and lightest tones is subtly graduated. Notice how putting the sphere against a dark background helps to throw it forward in the apparent space, and how the crescent of tone defining the sphere is darkest not at the very edge but slightly in from it. This imitates the reflection from the surface of the plane the sphere is resting on.

Next try a straight line drawing of a person in exactly the same way that you did with the pencil drawing – but remember that you can't fix errors with an eraser and go gently, using very delicate lines to explore the shape of the head.

Finally, draw some ordinary household objects from life, again restricting yourself to basic line drawing.

A Still Life in Pen and Ink

In this exercise you are going to take on the challenge of drawing a complete composition in pen and ink. Don't attempt a large-scale drawing at first – when you are more practised in the medium you can expand the size of your drawings, but it will take time.

I took a fairly simple still-life composition which does however have quite dark tones in it. This means that I had to work quite fast to get all the areas of tone built up to my satisfaction. If you want to avoid a lot of mark-making, choose a more brightly lit subject.

One of the tricky things about ink is its finality, which means that before you start on the ink drawing you may want to draw the outline in pencil to ensure that you have got the shapes right. This is how most commercial drawing in ink is done. You can then erase the pencil before you proceed with the rest of the drawing. Drawing in ink without first drawing in pencil is fun, but something to try out when the result is not critical.

Having produced a pencil outline of your composition, go over it very lightly in ink as shown here.

Then, as before, build a simple light tone over all the parts that are not highlighted, using vertical lines. As you can see the outline almost disappears when you do this, so don't make your lines too heavy or you will find it hard to see your composition amid the tone.

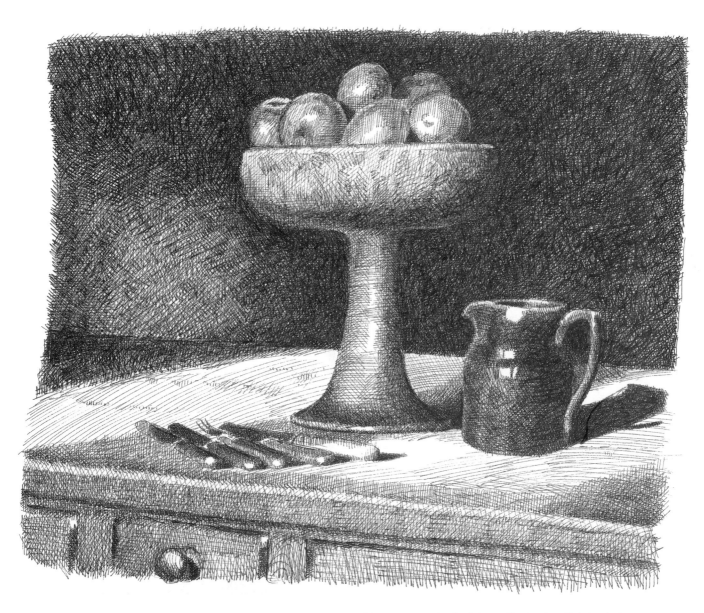

Now comes the build-up. Put in the slightly darker tone with multiple diagonal lines and then the next darkest with horizontal lines and so on, with lines going in the opposite diagonal to build even denser shadows. When you have done lines vertically, horizontally and in both diagonals, you will have to use strokes going in as many directions as you can to build up the very darkest shadows. Use curved lines as well and scribbly marks to fill up any areas that look too light in tone. This will all be quite painstaking, so you have to be prepared to put aside time for this medium.

BRUSH AND WASH

The technique of brush and wash is rather like traditional watercolour painting but without the colour, being only black and tones of grey. In my opinion the best medium is a black watercolour pigment, but some people prefer a diluted ink.

For working in this medium you will need: black watercolour pigment or black watersoluble ink; a china or plastic watercolour palette in which to dilute your pigment or ink; a jar for water, preferably glass so that you can easily see when you need to change the water (for a long session of work two jars are useful); and at least two brushes, sizes 2 and 10, to start with (later you may wish to add a size 6 and a really fat brush, especially as you get more expert). These should ideally be sable round brushes, which hold the most liquid and come to the best point and are correspondingly expensive, but if you don't want to spend large sums until you are sure you enjoy using the medium you can buy squirrel hair, or even nylon, which are adequate for a short time but lose their point fairly soon.

The first exercise is to draw in line with the brush. I drew this old horse using a fat brush, but you might find it easier to start with a thinner brush. As you can see, the quality of the line is quite different to all the other mediums that you've used so far. After a few trials you will be able to control the thickness of the line, but not entirely – half the fun is that this medium gives some very attractive variations on what you expect.

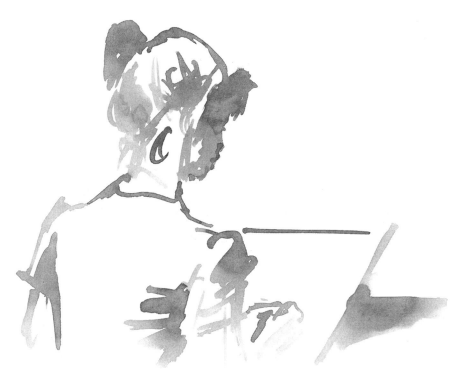

Then I drew a young girl practising her own drawing, again using the variation in the thickness of line to advantage. I wasn't too concerned about the light and shade in these first drawings, but sometimes when I saw an obvious area of tone I put it in with a quick flick of the brush. The small tube of paint was done in exactly the same way.

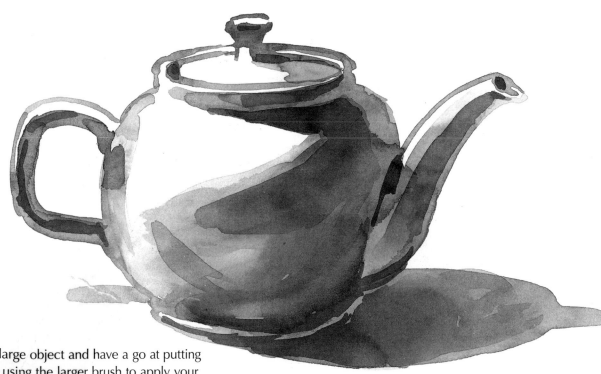

Now take a large object and have a go at putting in the tones, using the larger brush to apply your liquid quickly enough before it dries. The blending of tones is quite easy when it is still wet, but for the darker, more defined marks I waited until my paint had dried. You have to be both fast and patient with this medium.

A STILL LIFE IN BRUSH AND WASH

Having had some practice, you should feel confident enough with your handling of the brush to try something a bit more ambitious. I have chosen to use the same still life that figures in the pen and ink section. This way you can see how vastly the two techniques differ, while both arriving at an interesting result.

First you will have to draw out the shapes you are going to use with the thinnest brush, but if you are still doubtful of your ability to do this, just draw in pencil first and then go over it with the brush. Erase any pencil work left showing before you continue.

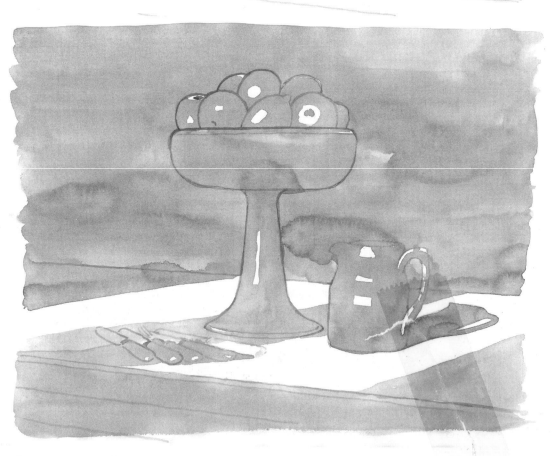

Then, once again, lay the lightest possible tone over every area of shadow in the picture. Leave only the very brightest areas of paper white and make sure you do not cover them over in subsequent layers.

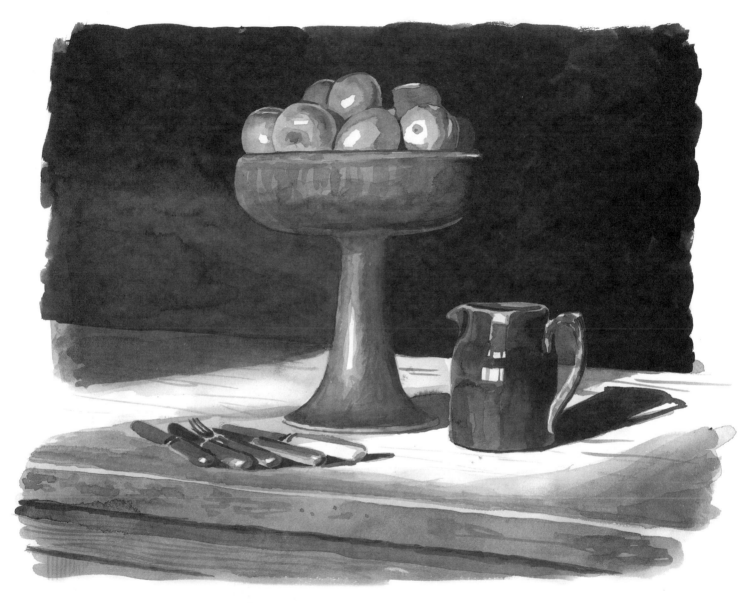

Now gradually build up the tones until you get to the deepest black where it is needed. Be careful here, as it is easy to darken tone too quickly and then find you have overdone it. And there you have your complete composition, which you can compare with your pencil, pastel and pen and ink drawings.

MIXED MEDIA

The last technique we are going to explore in this lesson is working with mixed media, combining some or all of the techniques used so far. You can also add collage to mixed media pieces, using glue to affix fabrics, paper and other materials; cutting up drawings that haven't worked out well to use them for collage gives you pieces of paper with line and tone already present.

The first subject is simple enough and I've chosen it as one that lends itself to a variety of mediums. This is a fairly flat, graphic kind of drawing, which I delineated carefully in a thin pencil line. Then I proceeded to draw in the hair and facial features with indelible ink from a graphic pen No. 0.1.

Next I took a pencil and drew in the texture of the jumper and the folds of the skirt, trying not to let the various mediums overlap each other. The only exception to this is on the face, where I put in a little shading.

Following this I painted in the background tone and the face and arms. Once that had dried I went over the face and arms again, because the skin tone is darker than the background. Finally I added the dark, rough-textured doorframe to the side using pastel, then fixed it to prevent it from smudging over the rest of the drawing.

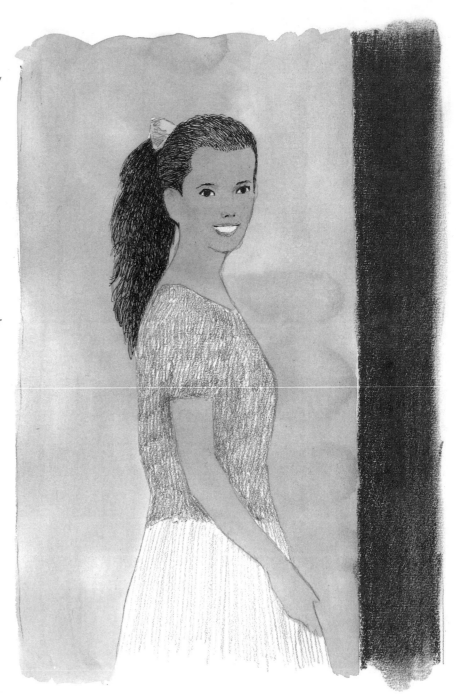

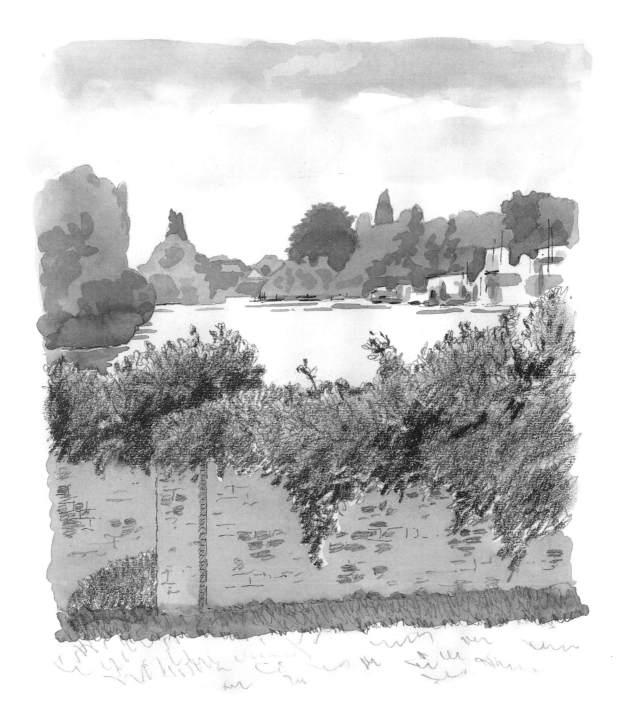

Next up is a similar exercise but with a small landscape, which you can try out from life. This view along the River Thames near Twickenham was drawn in summer, which in my view is the best time for landscape in England. Using a pencil, I lightly sketched the outline of the whole scene and then proceeded to work from the top downwards.

All the area above the foreground wall was done in wash and brush, achieving as much subtlety in the scene as I could. I then added a few pen and ink marks to the boats gathered by the side of the river. I carefully built up a texture in pencil over the whole of the vegetation growing over the wall, and put in some similar marks to indicate the brickwork on the wall and grass on the lawn.

Having done this I then covered the area of the wall and its shadow on the grass using a watercolour wash, making the shadow slightly darker than the wall.

Finally I scrawled in the wall vegetation with a charcoal pencil in order to give it a coarser texture than that of all the other vegetation, smudging it slightly with my thumb.

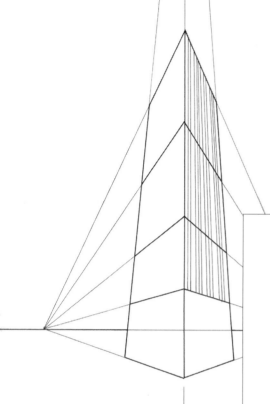

Lesson 6

PERSPECTIVE AND FORESHORTENING

As yet we have only considered perspective very briefly, so this lesson deals with it in more detail as it's an essential part of drawing visually believable pictures. The principles are not too difficult to understand and master, but some practice will be required before it becomes second nature and you are able to use it almost without thinking about it.

The first stages of learning about perspective are very theoretical and until you begin to apply it in practice you'll probably find it rather confusing; it's also not totally convincing without the application of direct observation as well. That is why those computer-generated apparently three-dimensional pictures always look slightly unreal. They work at a glance but if you have time to study them they don't have quite the subtlety that the observed world does.

With a bit of practice at drawing perspective you'll soon begin to see how it works in real life and you'll be able to make all the subtle adjustments that help to make your drawings more convincing. It may seem a rather dry topic, but do make sure you can handle this systematic rendering of the visual world before you get into the habit of drawing things that just don't look quite right to the viewer.

LOOKING AT PERSPECTIVE

The art of perspective is to convince the eye that it is looking at a scene in three dimensions, with depth and space. Here I have devised a series of exercises which, if copied exactly, will give you a good idea of how perspective views may be drawn.

One-Point Perspective

The first exercise deals with what is called one-point perspective. This means that there is only one point on the horizon line that all the main lines of the composition lead to. All other lines will be either horizontal or vertical.

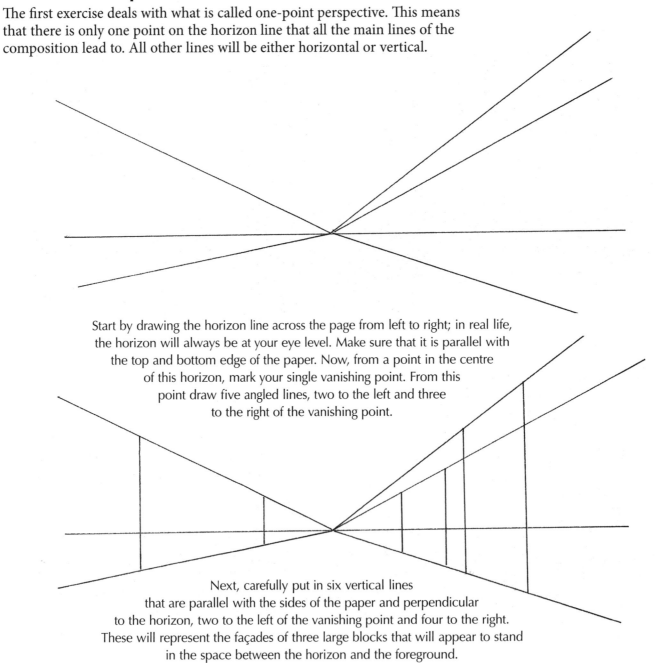

Start by drawing the horizon line across the page from left to right; in real life, the horizon will always be at your eye level. Make sure that it is parallel with the top and bottom edge of the paper. Now, from a point in the centre of this horizon, mark your single vanishing point. From this point draw five angled lines, two to the left and three to the right of the vanishing point.

Next, carefully put in six vertical lines that are parallel with the sides of the paper and perpendicular to the horizon, two to the left of the vanishing point and four to the right. These will represent the façades of three large blocks that will appear to stand in the space between the horizon and the foreground.

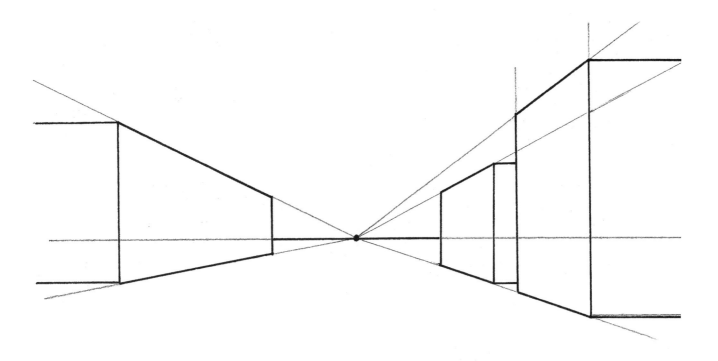

Finally, you will need to put in six horizontal lines that start from the top and
bottom of these verticals, on the left striking off to the left and on the right
striking off to the right. Now, when you erase your guidelines, you will have
what appear to be three large blocks set in the space described.

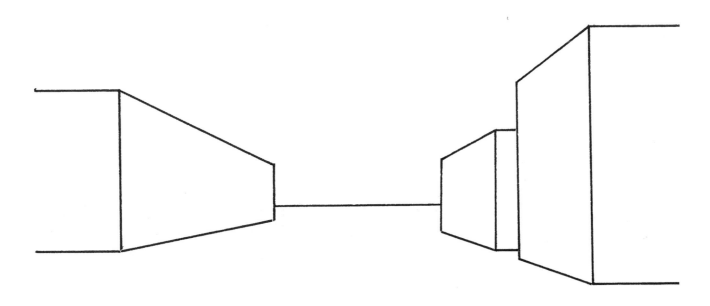

Two-Point Perspective

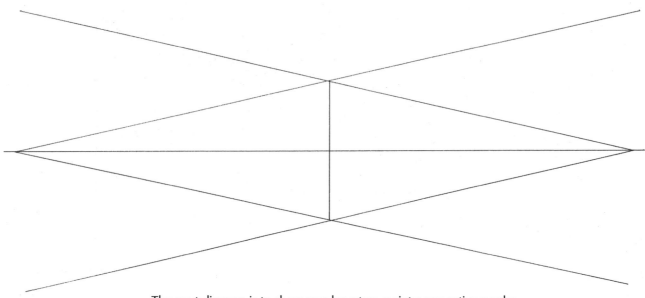

The next diagram is to show you how two-point perspective works.
Again, first draw the horizon line across the page, making sure that it is parallel to the top and bottom edges of the paper. Then mark two vanishing points, one on the far left and one on the far right. In the centre draw a shorter vertical line, perpendicular to the horizon and bisecting it, as shown. Now draw lines from the vanishing points to meet the top and bottom of the vertical line at the centre, and extend them across the page, as shown.

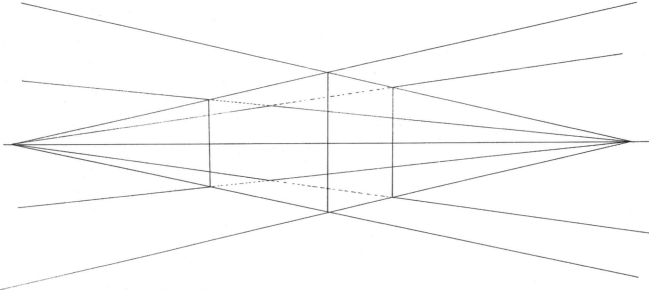

To construct the block so that it appears three-dimensional in the scene, you now have to draw two more verticals, parallel to the first, the one to the left further from it than the one to the right. End them both at the lines of perspective, top and bottom, that you have already drawn. Then from the two vanishing points draw two more perspective lines, from the left crossing over to meet the top and bottom of the vertical on the right, and from the right to meet the top and bottom of the vertical on the left. This produces a framework for the block apparently set in space.

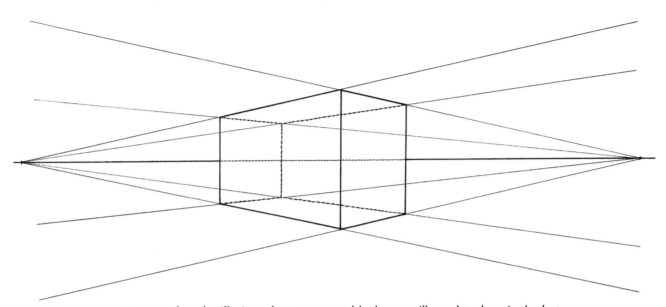

To complete the illusion of a transparent block you will need to draw in the last
vertical, which would be hidden if the block were solid. This spans the points where
the last sets of perspective lines cross each other. So once again you have drawn an
apparently three-dimensional block, but this time transparent.

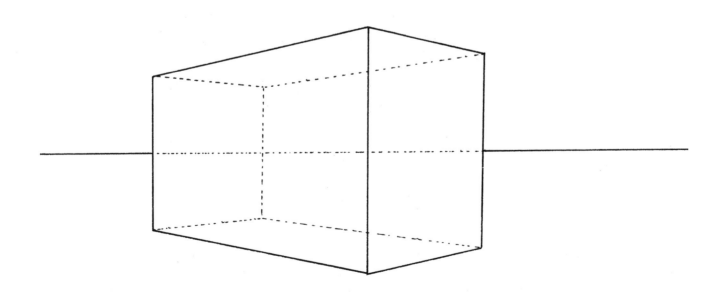

Three-Point Perspective

Three-point perspective is not often used, but I am demonstrating it here as it helps to complete your understanding of how perspective works. It applies to drawing very tall buildings, and is not so easy to see in real life unless you are standing near the foot of one.

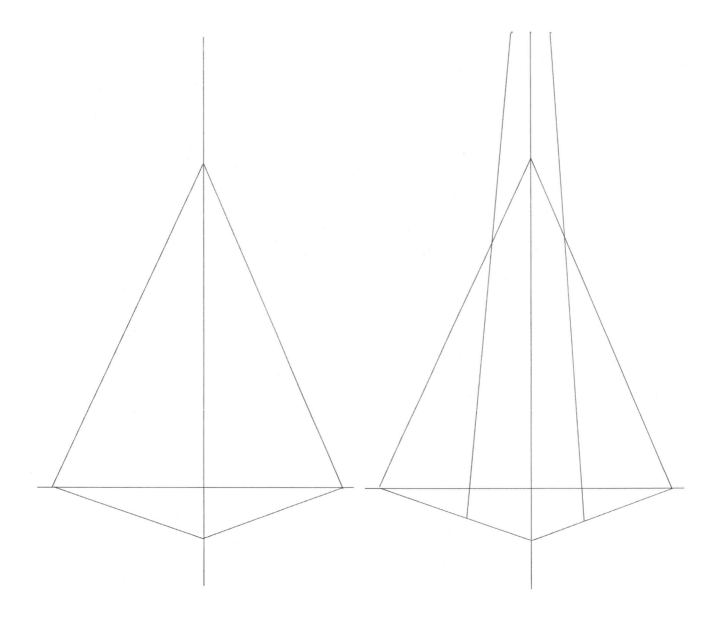

First, as before, draw a horizon line across the paper, and after fixing two vanishing points to the left and right, join them to a long vertical drawn in the centre as before at the top and bottom, only the top point should be as far up as you can get on the paper, while the lower point should be close to the eye-level line. This, as you can see, creates a very tall quadrilateral.

Now draw two lines either side of the central vertical so that they incline equally inwards at the top, as if you had a third vertical vanishing point somewhere high above the horizon – so high above, in fact, that you would need an enormous sheet of paper to accommodate it.

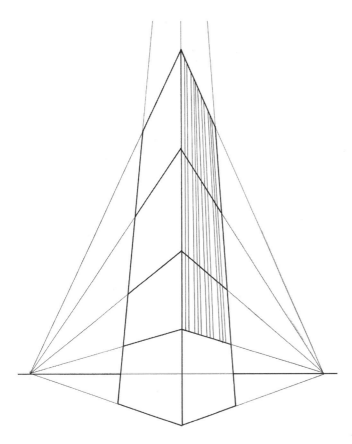

Draw in some more lines from the two vanishing points that you can see to indicate different levels on the surface of this tall block, so that it looks like a sky-scraper.

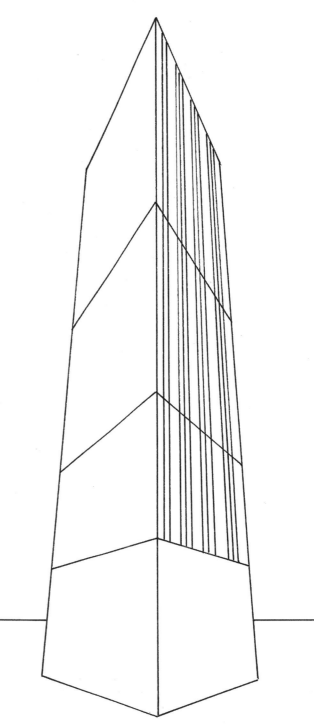

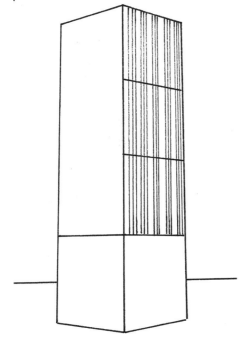

This diagram is more like the form you might actually see, but it would require a massive sheet of paper to actually draw it as a complete diagram.

A few more off-vertical lines on one side of the block will increase the drama of the perspective and will give an impression of a tall building, seen from below. Of course, the angularity of the block is vastly exaggerated, but one can get the idea. Remember, perspective is only a way of helping to cheat the eye to believe in the solidity of buildings and the depth of space – it tends to break down if you try to take it too literally.

A Perspective Diagram

This purely diagrammatic exercise is intended to give you practice in drawing perspective, so that eventually you will be able to draw it without all the construction lines because your mind has absorbed its principles. The co-ordination of the eye and mind is melded by repetition and practice.

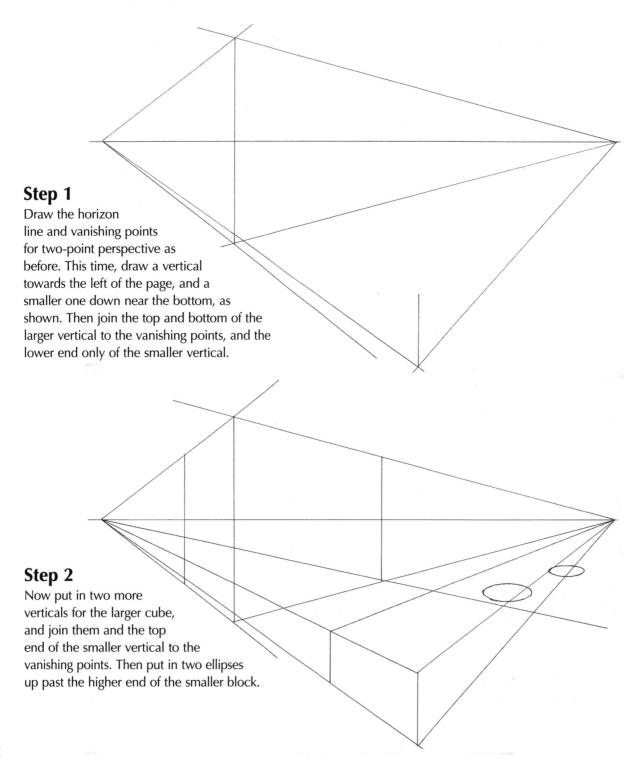

Step 1

Draw the horizon line and vanishing points for two-point perspective as before. This time, draw a vertical towards the left of the page, and a smaller one down near the bottom, as shown. Then join the top and bottom of the larger vertical to the vanishing points, and the lower end only of the smaller vertical.

Step 2

Now put in two more verticals for the larger cube, and join them and the top end of the smaller vertical to the vanishing points. Then put in two ellipses up past the higher end of the smaller block.

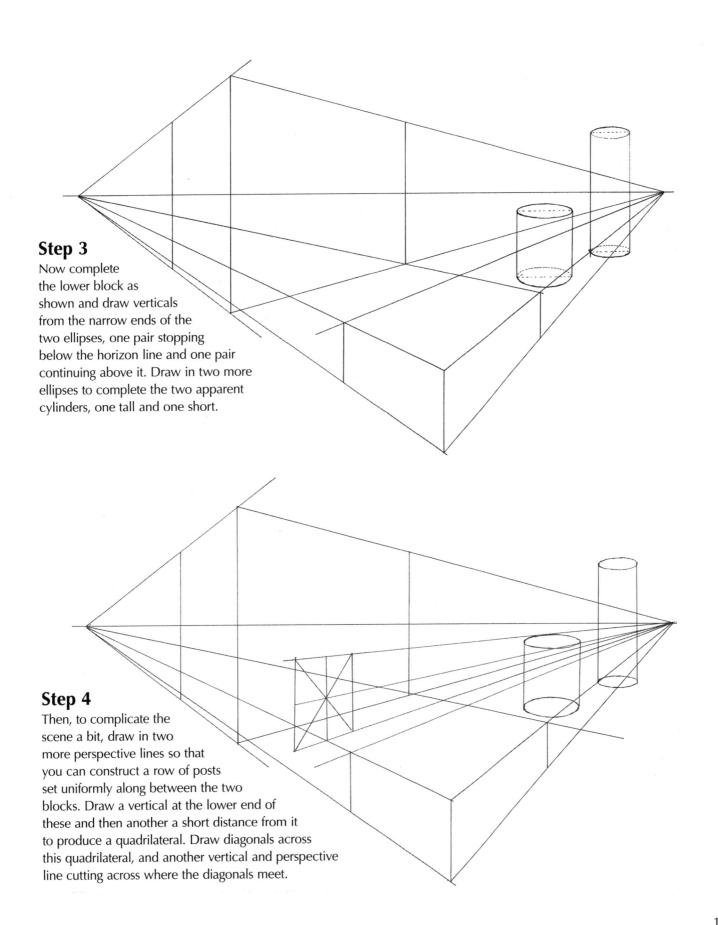

Step 3

Now complete
the lower block as
shown and draw verticals
from the narrow ends of the
two ellipses, one pair stopping
below the horizon line and one pair
continuing above it. Draw in two more
ellipses to complete the two apparent
cylinders, one tall and one short.

Step 4

Then, to complicate the
scene a bit, draw in two
more perspective lines so that
you can construct a row of posts
set uniformly along between the two
blocks. Draw a vertical at the lower end of
these and then another a short distance from it
to produce a quadrilateral. Draw diagonals across
this quadrilateral, and another vertical and perspective
line cutting across where the diagonals meet.

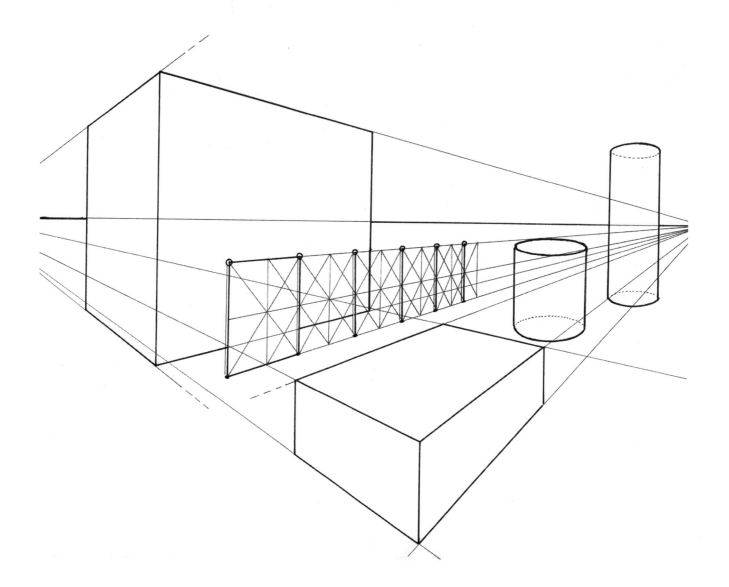

Step 5

Using the method shown on page 103 to draw a row of posts in perspective, keep producing diagonals that use the next central point to construct another vertical until you have a whole row of them.

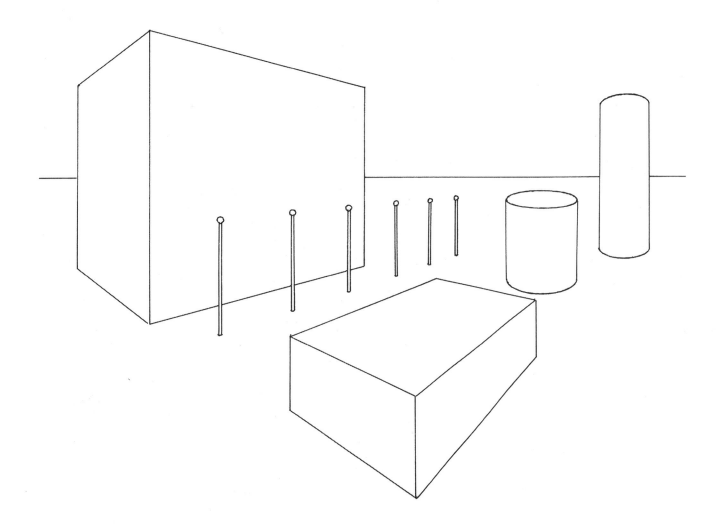

When you have erased your construction lines the whole diagram should look like this. This exercise can take a bit of time, but it is well worth trying out to consolidate your perspective drawing skills. The result should be solid-looking and convince the eye.

An Indoor Scene in Perspective

The final perspective exercise is simpler to stage than the previous ones, because you only have to look around you at the room you are in to see your next subject. That doesn't mean that the task is any easier when it comes to drawing it, but at least you have now had quite a bit of practice of drawing in perspective, so you will be much more confident of tackling the problem.

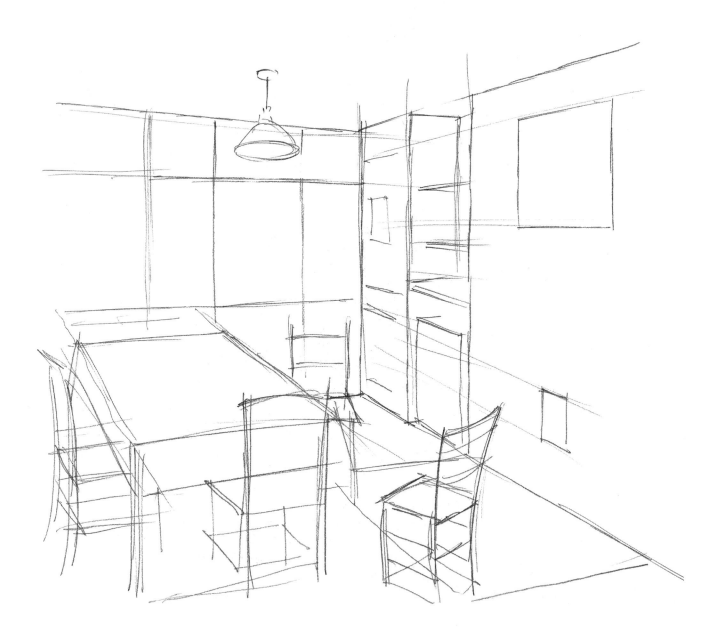

Step 1

First of all, look at this initial sketch of an interior. It will be immediately obvious to you from your studies so far that this scene is using perspective lines to construct the drawing.

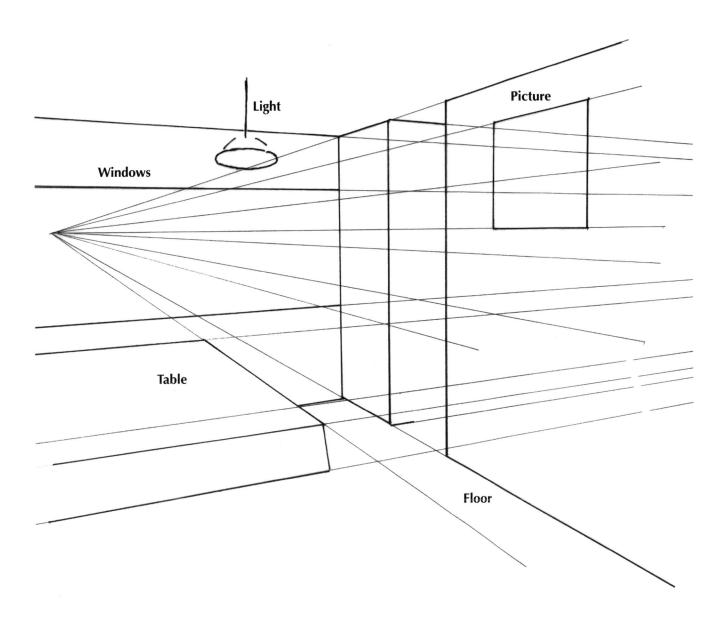

Light

Picture

Windows

Table

Floor

Step 2

The next diagram shows perspective lines laid over the sketch to help verify my view of the room. You will find that the hardest parts of your own room to see properly are those at the periphery of your vision, in which there is often some slight distortion that would look odd in the drawing. You may have to correct or ignore some of the apparent image at the very edge of your vision.

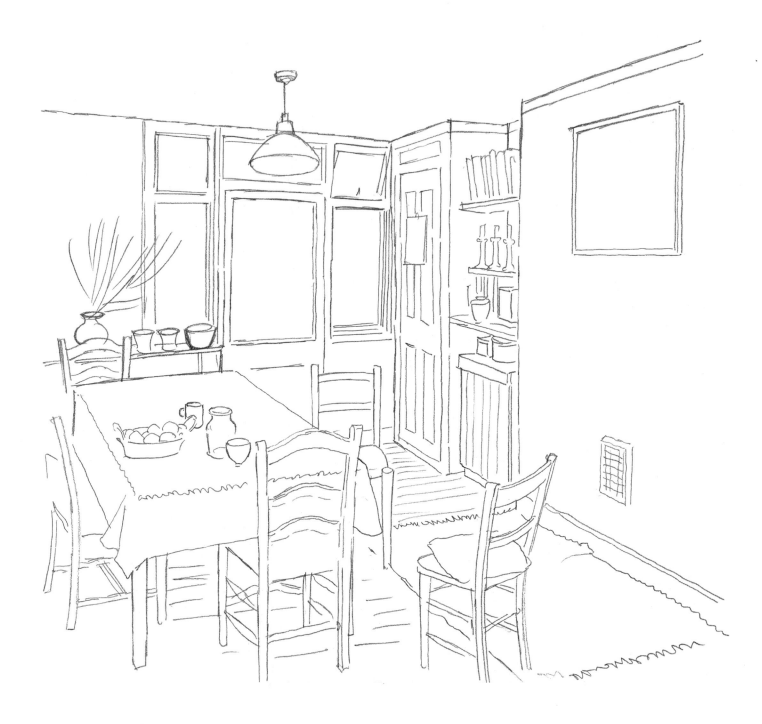

Step 3

Once you've constructed a sketch that you think holds the image correctly, begin to put in the main outlines of the room and furniture within your field of vision. However, if there are any complicated pieces of furniture or objects that make things more difficult, remove them from view or simply leave them out of your drawing. All artists learn to adjust the scene in front of them in order to simplify it or make it more interesting and compositionally satisfying; you can see this in the topographical work of Turner, Canaletto or Guardi, for example. The lines of perspective should enable you to get the proportions of the objects in the scene accurate.

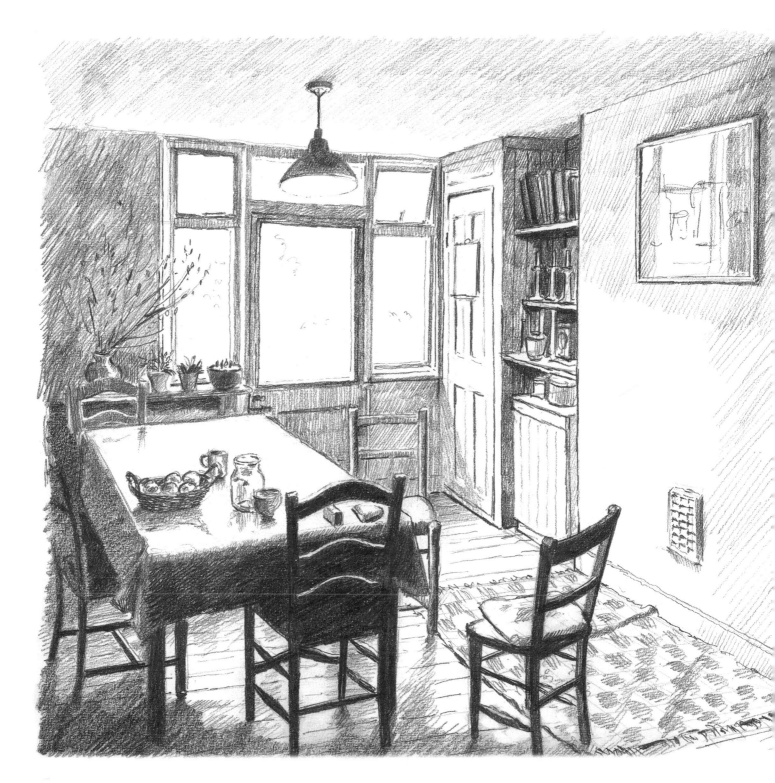

Step 4

You can then work on the tonal values of the scene to give it atmosphere and depth. If you have to leave it and come back later, check that the furniture hasn't been moved and that the angle of light is similar to the time before – if the weather is sunny and you try to resume at a different time of day you will potentially find the lights and darks very differently placed. The lighting in my scene is partly from the windows and partly from the overhead electric light. Notice how I have built up the tone to a strong black in the chairs nearest to my viewpoint.

Foreshortening the Human Figure

Here we are concerned with the effects of perspective on the human body when it is seen from an extreme angle. While you may never want to draw someone lying flat out vertically towards you, it will often be the case that you will draw poses where some parts of the figure are closer to you than others, and the same rules of perspective apply. So the exercise here is to find someone to lie on the ground or on a couch, as flat as possible, preferably on their back. Your position should be seated so that you can see them from the feet and then the head, from an eye-level not far above them.

When you first try this exercise in drawing, the difficulty is in being convinced by the way the legs or head seem to disappear from view, so that there is hardly any length to them in the drawing. It can look unnaturally distorted if you are unused to considering perspective. Nevertheless, your eyes are very good at seeing accurately, and it is only your ideas that make it hard for you to believe what you see. Notice on the male figure how the area covered by the legs and feet is larger than the area of the torso and head, even though we know that, if seen standing up, they would be similar in size.

Also, on the female figure, the head and shoulders seem very big compared to the size of the rest of the body, which recedes from the viewer. It underlines the fact that we perceive objects close to us as larger than those further away. For example, bend your arm, look at your open palm in front of you and watch the size of your hand apparently grow as you bring it towards your nose.

So, when you start to draw your recumbent figure, you may need to draw two lines indicating the way the figure diminishes as it recedes from your viewing point. My two first sketches give you some idea how this might work.

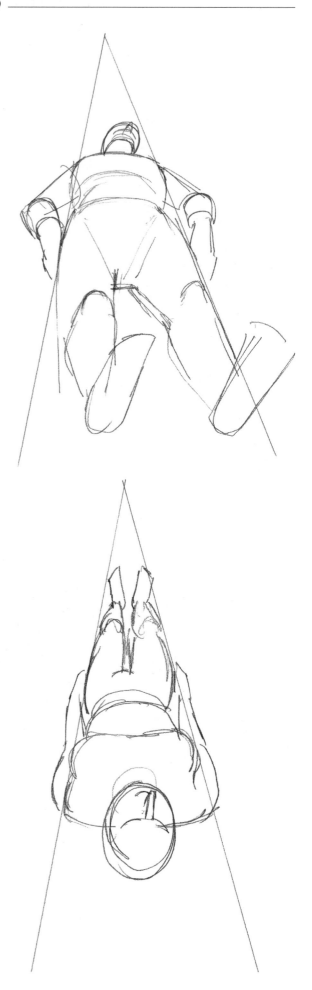

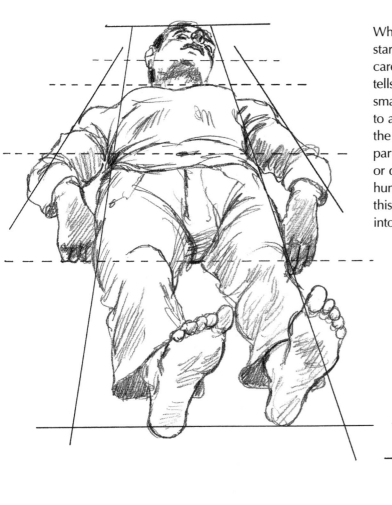

When you have blocked in the main forms quite simply, start to draw in the larger shapes, remembering to carefully follow what you observe, not what your mind tells you. Don't be tempted at this stage to put in any small detail; simplicity and accuracy is what you are trying to achieve. Once again, measure how the far parts of the body appear to you in comparison with the nearest parts to ensure that you don't start to enlarge the former or diminish the latter to accord with what you think the human body should look like – many beginners do just this, and it takes a bit of practice before the message sinks into the mental processes.

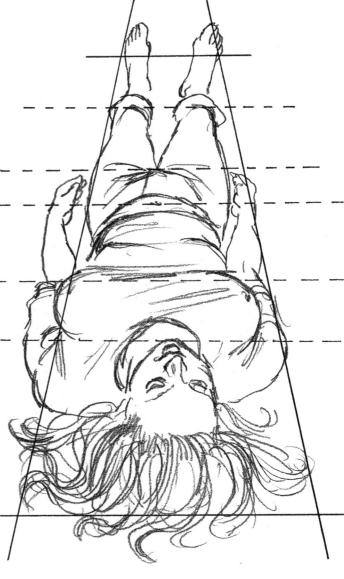

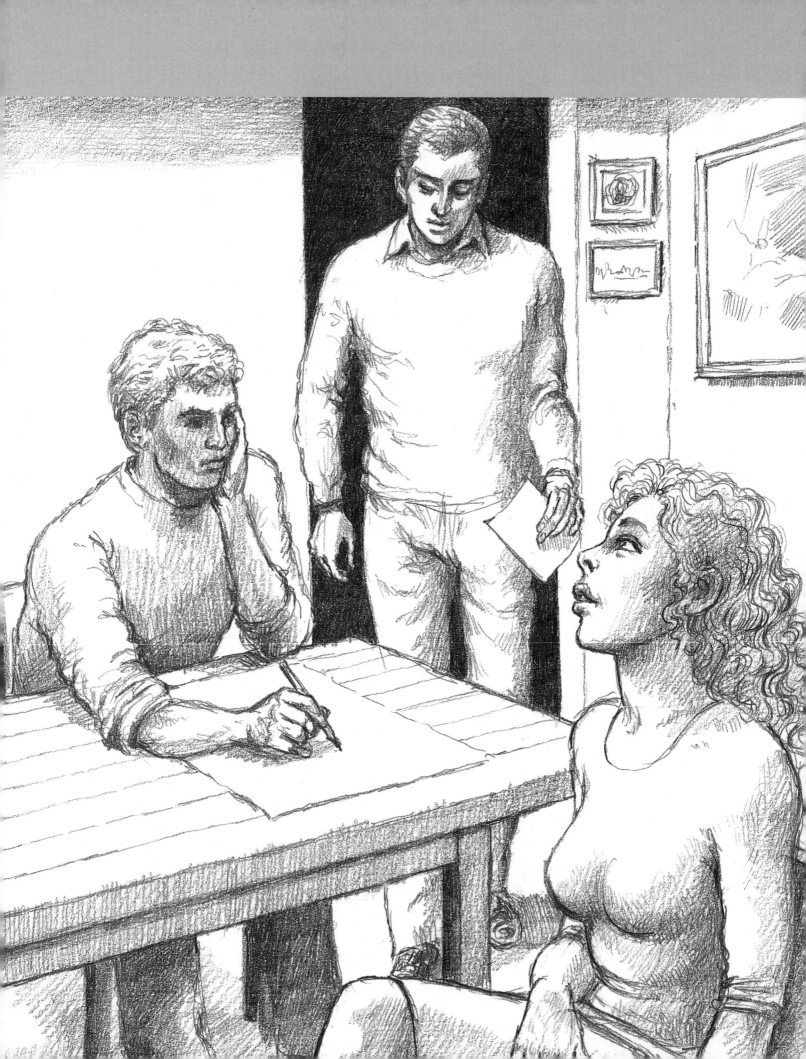

COMPOSITION

The most creative possibilities for an artist come from the process of composition. No matter how well you have learned to draw objects, animals, figures or landscapes, until you have considered the question of composition you have arrived at satisfying pictures only by accident. The intellectual process of determining how the individual elements of a picture hang together is what differentiates the accomplished artist from the beginner.

There are many routes by which to arrive at a strong composition and this lesson will not by any means be exhausting all the possibilities, but you will discover several time-honoured methods of going about it. Of course an artist soon develops an eye to arranging his or her elements in such a way that the result is interesting, but there are techniques to provide guidance in this.

It is often a question of balance, or sometimes imbalance, that gives a composition its power. This lesson discusses how to divide the surface of your picture in such a way that it will give an interesting balance of shapes and ends with a specific exercise in practising a composition that should help you to get to grips with the basics.

Lesson 7

CREATING A BALANCED COMPOSITION

Dividing the page

This exercise is concerned with dividing up your page so that you may construct a balanced composition on it. It's not by any means the only way to do it, but it's probably the simplest at this stage of your development.

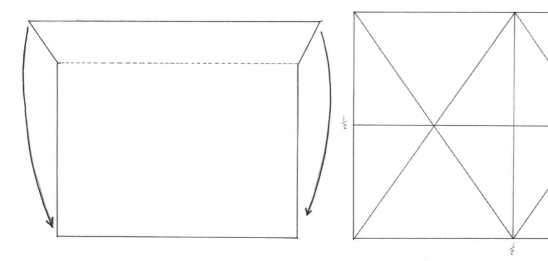

The first step is to take your A3 or A4 paper and fold it in half. Be exact about this, because your other measurements rely on it. Unfold the paper and draw a line along the fold, then divide both rectangles with diagonals from corner to corner. Where they cross, draw a line horizontally across the whole paper from centre to centre, extending to the edges. You now have your paper divided in half vertically and horizontally, without measuring anything – a simple device but effective.

You can now draw two diagonals across the whole paper from the corners. They should cross each other at the centre point if your lines are precise enough.

Your last divisions are to draw horizontals and verticals from where the main big diagonal cuts across the two sets of diagonals of the half pages. These will be the third divisions of the page which already has the halves and quarter divisions. You now have a template to divide any piece of paper of the same size into halves, quarters and thirds, and the next examples will show you simple ways in which to use it to create compositions.

Dividing the page: practice

The first composition is one where a tree stands one-third from the right and two-thirds from the left of the scene. Its roots are at the lowest quarter mark. Across the picture at the lower third mark is a fence that appears to stretch about halfway. The horizon in the background is one-third from the top of the picture. There is a lone tree in the distance which is about one-third away from the left hand side of the composition. As you can see, it all looks a satisfactory balance.

The next picture is a still life which uses a similar format. This time the largest vase is on the left third vertical, one-quarter from the top and one-quarter from the bottom. The rest of the objects are mainly on the right-hand vertical, with the ones projecting out at the third and halfway marks. Once again this creates a well-balanced composition.

The two remaining pictures are both in a landscape format. First, a figure composition with two people, one sitting and one standing. The standing figure is one-third from the right edge of the picture and almost touches the top and bottom edge. The seated figure is near a wall that projects from the left-hand side of the picture to a third of the way across. This very simple design already gives an interesting tension between the two figures.

The last example is of a townscape in which one foreground building projects from the right to about one-third across, and from the top of the picture to about one-third from the lower edge. The other main block is projecting from the left to about one-third of the way across, with the top one-quarter from the top edge of the picture and the bottom edge at the halfway point. I've then put a lone block in the distant piazza at the halfway mark vertically and just below the quarter mark horizontally. A little vegetation in the lower left at the quarter horizontally could soften the hard edges of the buildings.

As you can see from these examples, a simple reduction of your page to thirds, quarters and halves can give you a number of compositional schemes to play with.

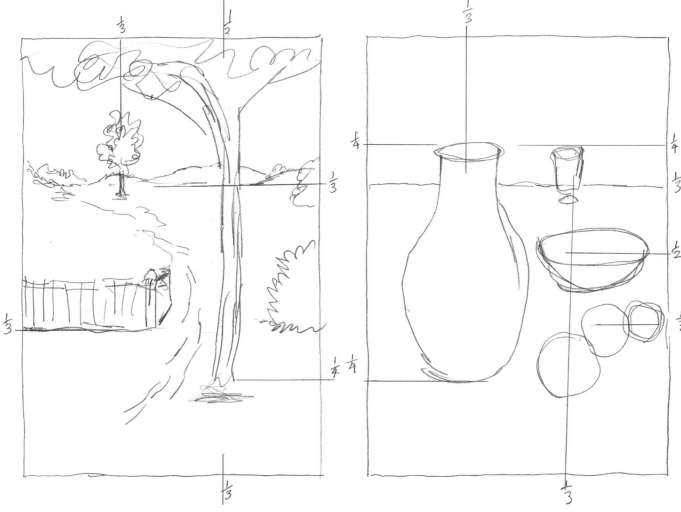

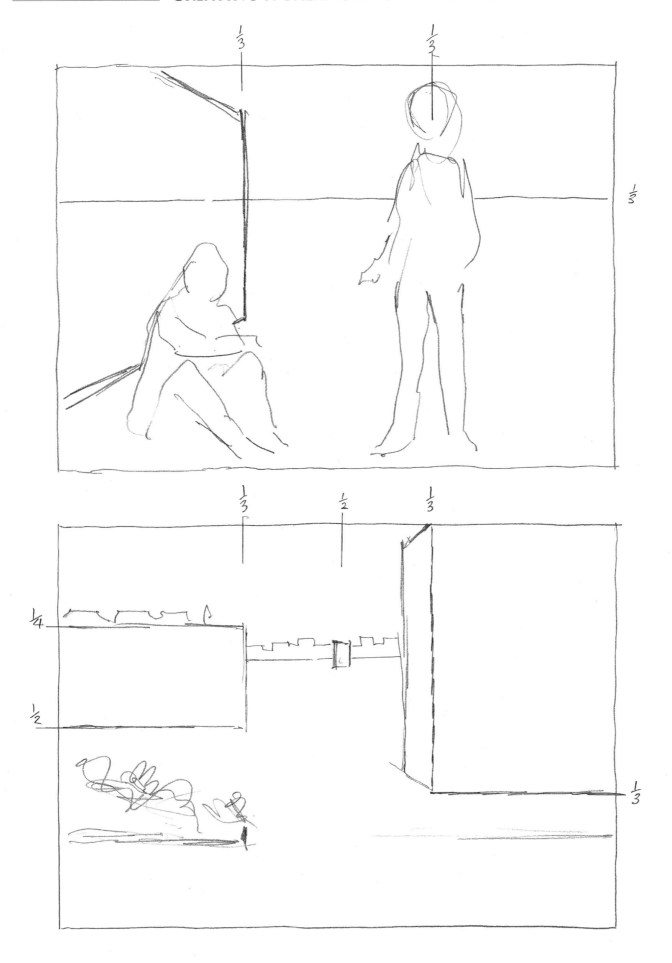

DESIGNING A FIGURE COMPOSITION

Now we are going to have a go at producing a complete figure composition. This will be done in a very practical way, with me drawing up a composition that you may want to copy, or you may wish to do something similar without necessarily reproducing my picture. I will show you step by step how I might go about it, and you can then apply the same system to your own creation.

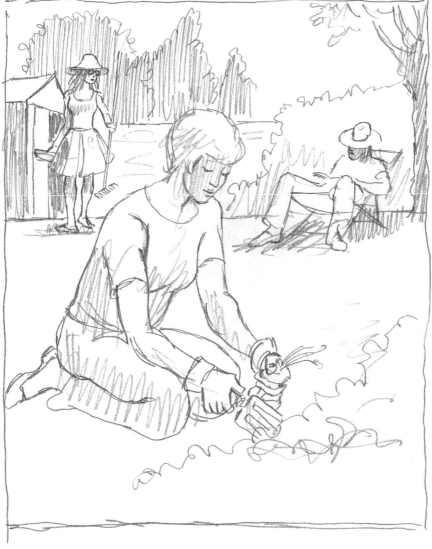

Step 1

I've started by using two slightly different formats, imagining a simple scene that I know well. If you want to make your own picture think of something familiar in your life, as it will lend verisimilitude to the composition.

In one picture I've put three figures in a garden setting. The nearest figure is a woman kneeling by a flowerbed with a garden tool in her hand. She is almost centre but just off to the left to create some space on the right. In that space is a male figure sitting in a deckchair, rather far back in the scene. To the left of the main figure is another woman walking towards her. The trees in the next garden go across the picture at about a third of the way from the top.

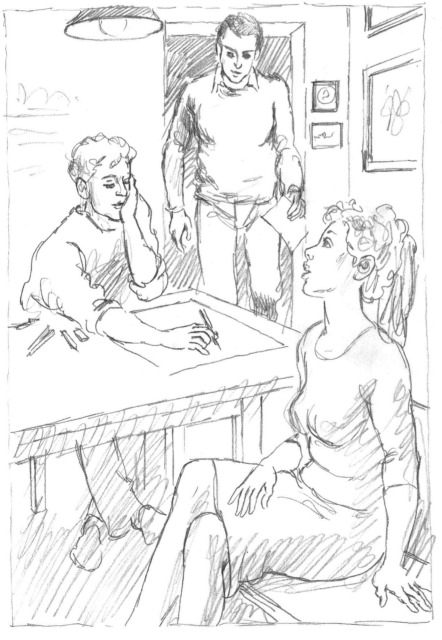

Again taking a familiar scene, I decided to draw an artist with a model, adding another figure to complicate the matter a little. I placed the artist at a table which juts across the centre of the space, with him behind it and his model in front to the right. I made his model a girl and the other figure a male walking forward into the room.

The model is the largest figure, and her feet are not visible. She sits in the right-hand corner of the picture, taking up about one-third of the scene diagonally across the picture. The artist is the next nearest but he is hidden by the table from his waist up. The third figure is almost in the centre of the picture, but further back as though coming through a doorway. This is design number two.

119

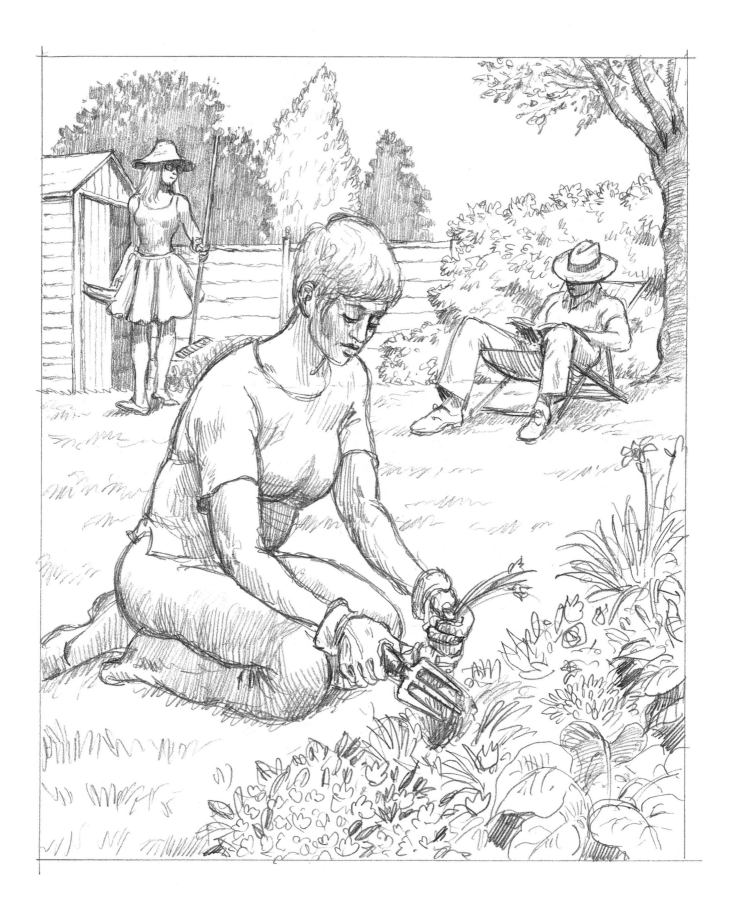

Step 2

Having produced a rough draft of the pictures, I still couldn't make up my mind which one to follow, so I drew them both up more seriously in greater detail. This may take you some time, and it's the stage where you decide exactly what everything is going to look like. You may decide halfway through drawing one picture that you prefer the other one, and if so you can stop and just concentrate on the one of your choice. Stopping short with one of them doesn't matter – this is an exercise in coming to your final decision.

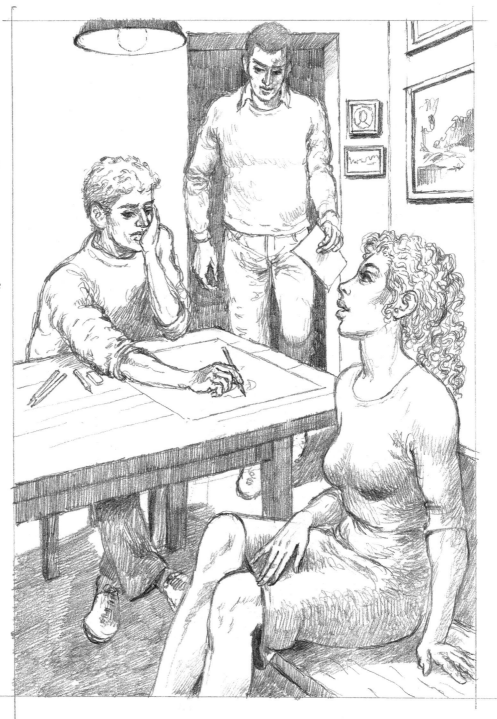

Step 3

My decision was to go with the artist drawing the model, and now I needed to consider it in more detail.

First I decided what the main figure would really look like. Ideally I would find a person to model for me, and after getting her to sit in the correct pose for my composition I would carefully draw her from life. If that were not possible I would work from my own previous drawings or use photographic reference.

As you can see I drew her head twice in different positions and also made a sketch of her nearest hand. All this acted as useful information for the final picture.

Then I moved on to the other two figures, getting some idea of how the artist would look and how the other man would actually approach the scene. As you can see, I tried different positions for the head of the walking man.

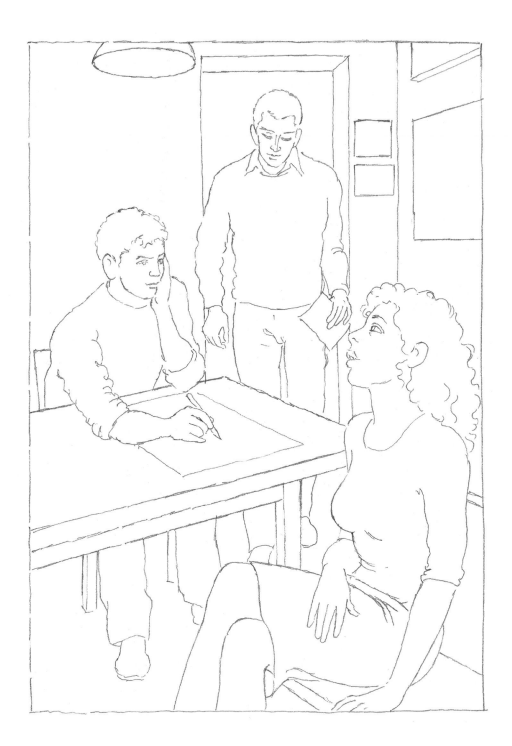

Step 4

Having researched the figures I now put them all into context by drawing up what is known as a cartoon, which is an outline of the complete picture. This was the last stage where I could alter the scene if required. Keep a version of this cartoon to enable you to correct any details when you have put in the tone.

Having got the full picture drawn up in line, I could now put in the main areas of tone or shadow in one light tone (opposite). At this stage don't overdo the weight of tone, because you will find it harder to get rid of it than to add more if you need to. It shows you where the light is coming from and gives you an idea as to how solid your figures may look.

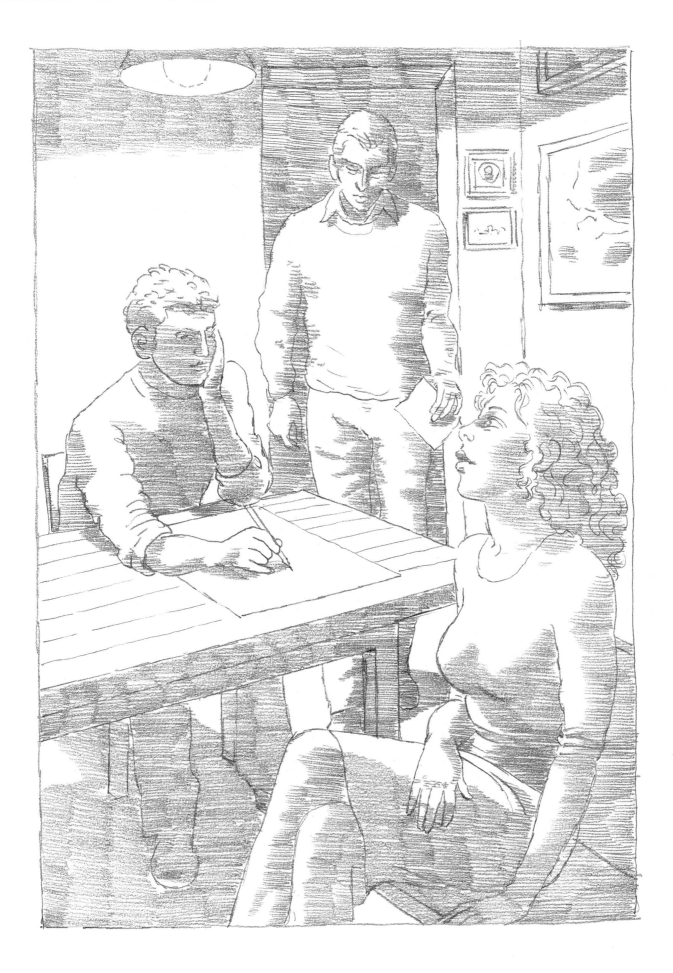

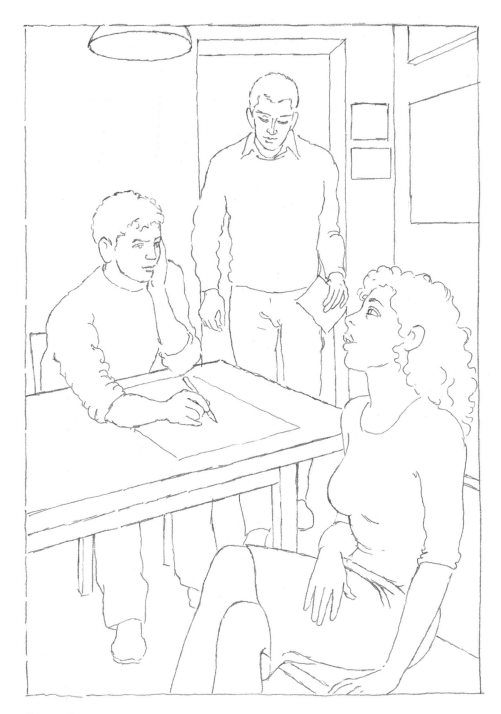

Step 5

Now comes the final stage, where everything is put in with great detail. Using your copy of the cartoon to ensure that all the shapes remain correct, begin to build up the heaviest tones so that you can see how the depth of space works in your composition. Take your time, because the quality of your work depends on the care and attention that you give to this finishing stage.

So now you have your completed composition with all the preliminary drawings that you made. Keep these for a while, because they might be useful in later drawings. In the ateliers of old, the drawings made for pictures were always kept for quite a time to be used over and over again in other compositions.

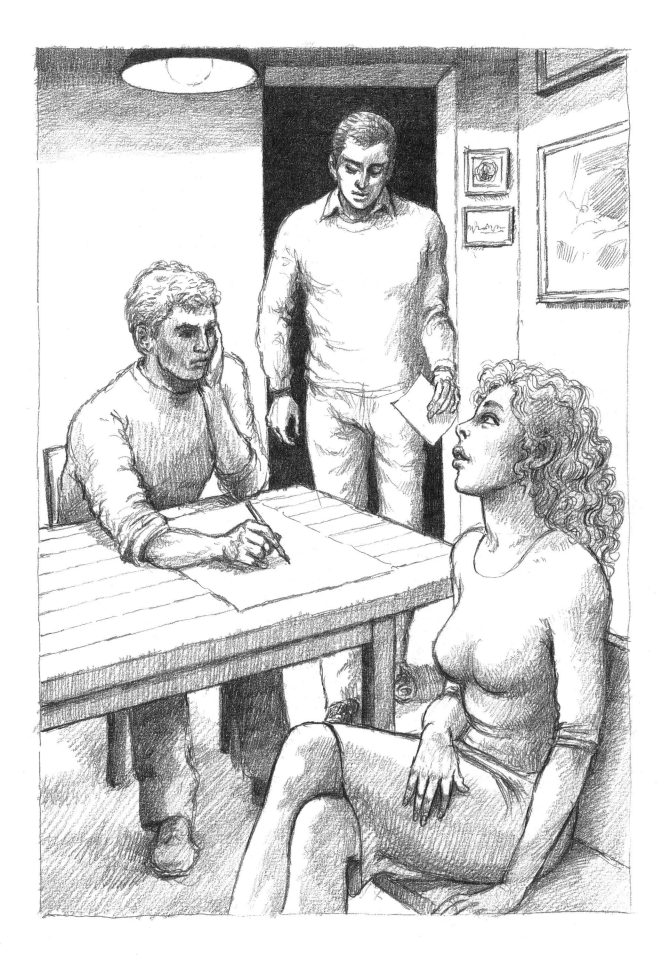

Index